IMAGES
of America

EASTHAM

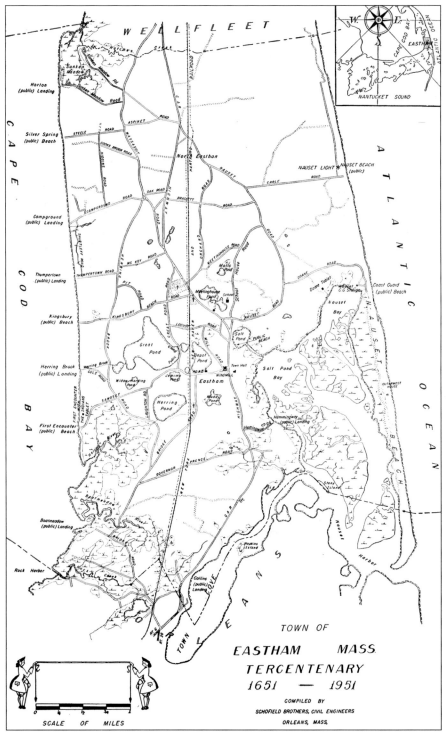

This map, drawn in 1951 for the 300th anniversary of Eastham, shows the unique characteristics of a land bordered by both the Atlantic Ocean and Cape Cod Bay. Wellfleet and Orleans were once part of the original settlement of Eastham.

IMAGES
of America

EASTHAM

Marilyn C. Schofield and Roberta Cornish
for the Eastham Historical Society

ARCADIA

Copyright © 2003 by Eastham Historical Society.
ISBN 0-7385-1176-5

First printed in 2003.

Published by Arcadia Publishing,
an imprint of Tempus Publishing Inc.
2A Cumberland Street
Charleston, SC 29401

Printed in Great Britain.

Library of Congress Catalog Card Number: 2002117432

For all general information, contact Arcadia Publishing:
Telephone 843-853-2070
Fax 843-853-0044
E-mail sales@arcadiapublishing.com

For customer service and orders:
Toll-free 1-888-313-2665

Visit us on the Internet at www.arcadiapublishing.com.

The seven founding families of Eastham called their settlement Nawsett after the Native American settlement in the area. In 1651, when the town was incorporated, the name was changed to Eastham. In the official seal, note the use of the wheat sheaf under the shield. One of the factors that made the area so desirable was the richness of the land at that time. Eastham later became known as "the Bread Basket of the Cape."

CONTENTS

ACKNOWLEDGMENTS

The authors would like to acknowledge those who gave their time and efforts to make this book possible: Laura Peters, Elisabeth Sandler, and Don and Pam Andersen of the Overlook Inn. Most of the images in this book are taken from materials held by the archives of the Eastham Historical Society. They have been collected and donated by Eastham families and others who hold Eastham dear to their hearts. Thanks go to them all.

The Eastham Historical Society is always grateful to families and individuals who continue to add to our collection of Eastham family and town histories. The collection includes journals, diaries, letters, mementos, photographs, and other artifacts.

Profits and royalties from the publication of *Eastham* will be used to expand the programs and improvements to the museums and archives of the Eastham Historical Society.

INTRODUCTION

The February 1978 blizzard that came screaming into New England from the northeast created more havoc on Cape Cod in two days than had been experienced in the previous 20 years. Great chunks of the outer land barriers and dunes were lost into the churning seas. At the Cape Cod National Seashore in Eastham, the parking lot at the beach was reduced to rubble, while cottages and landmarks were swept out to sea. The following day, the storm appeared to abate. Residents and visitors alike made their way to vantage points at Coast Guard Beach and Fort Hill. Suddenly the sun came out, and the temperature hit almost 60 degrees. Festivity filled the air at the sudden change. People gathered and chatted. Thermos bottles of drinks appeared, and snacks were passed around. The scene resembled the annual local June Strawberry Festival. Then, without warning, the sun disappeared behind black swirling clouds. The winds once again began to howl, and the temperature plummeted. Families scattered to safety before realizing that the sunny respite had been only the eye of a monster storm that continued to rage on into the night.

It seems fitting to start this pictorial history of Eastham with an example of how nature has always helped to carve and mold its landscape. When one realizes how much this act of nature changed our very modern community, just think back to the very earliest people who lived here. In 1990, the sharp eyes of a young father walking the outer beach with his children spotted an unusual configuration in the base of a high dune. An amateur archeology student, the father immediately alerted Cape Cod National Seashore headquarters. For the next six weeks, experts fought against time and tide to undertake an excavation of the site before the winter storms could destroy it. From this one small site on the beach came enough evidence to indicate that the first inhabitants of Eastham were here over 7,000 years ago.

When Eastham was first settled by members of the Plymouth Colony in 1644, the territory was bounded on the east by the Atlantic Ocean and on the west by Cape Cod Bay. Between these two points, the land area was a mere three to four miles in width. From north to south, the span was considerably greater. It included the area that today we know as Truro, and it continued to the south as far as the Chatham line. It is no wonder that so much of our history revolves around the ocean. From these sturdy early settlers have come ships' masters and owners, whalers, fishermen, and Grand Bankers. Along with these men emerged strong women who, in the absence of their husbands, conducted family business, parented children, tended to animals and crops, and kept up their homesteads. Such was the combined strength of these families as they entered the 20th century.

This book is an invitation to take a journey back in time from a stormy day in February 1978 to the early days of the camera in Eastham. We do not pretend that it is a complete picture of life in Eastham but merely a composite of images that have remained from days gone by. It should be mentioned that a camera in the 1800s was a luxury, and we are fortunate that two young women in Eastham—Bessie Penniman and Matilda Smart—were able to record a segment of their lives for us. Unfortunately, this was not so for most people; glaringly absent are photographs of fishermen, farmers, housewives, and homesteads. Something as simple as barnyard animals, which provided food, clothing, agricultural power, and transportation throughout the period covered by this book, have almost completely disappeared from Eastham, and our children today are forced to attend reconstructed Colonial village museums to experience this part of everyday life.

The Eastham Historical Society is dedicated to preserving the past of Eastham with two separate museums. The first one is the one-room Schoolhouse Museum, on Doane Road, and the second is the Swift-Daley Museum complex, on Route 6. Included in this museum is the original homestead of the Swift family, and on the outlying grounds are the Dill Beach Shack and the Ranlett Tool Barn, an amazing collection of old tools and blacksmith shop. For the researcher and serious student of Eastham history, archives are located in the Eastham Public Library. Please enjoy this little slice of Eastham.

—Marilyn C. Schofield
Eastham, Massachusetts

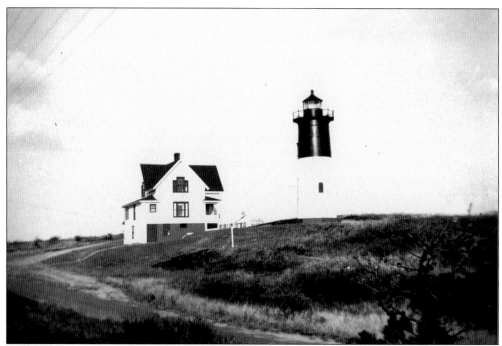

When this late-1940s photograph was taken, Nauset Light was still part of the Coast Guard operation in Eastham. All Coast Guard buildings were traditionally white with red roofs. Later, when this keeper's house was sold to a private owner, it was shingled but kept the traditional red roof. In the early 1990s, when erosion threatened to topple the structure into the sea, a grass-roots swell of volunteers from Eastham worked tirelessly to save the light, and it was moved back from the bluff. On a snowy afternoon in December, the familiar "I Love You" light shone for the last time on the high bluff. Hanging from the upper portion of the lighthouse was a Christmas wreath and a sign reading, "Thank you!"

One
IN THE BEGINNING

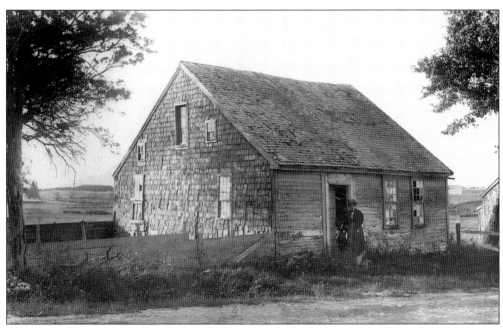

The original home of Gov. Thomas Prence, one of Eastham's first settlers, is pictured here. Prence served three terms as governor of the Plymouth Colony. He served two terms while still living at Plymouth and served his third term after moving to Eastham in 1644. This was most remarkable not only because of the distance between the Plymouth and Eastham settlements but because of the length of time served (1657–1673). By the early 1900s, this building was being used for the penning of pigs.

In 1711. at Billingsgate who petitioned were the following Indians

James Mark Harriet Young Joab Moses John Loving Harriet Keys Samuel Abd — Moses Moses Tom Tobi Sion Thomas Sam Trip Joange Abram Joseph Thomas Sam Robbins Jeremiah Robbins James Mark Jr John Joange James Joange Judah Joange Daniel Abram.

The abovenamed Indians petitioned in relation to some rights See their petition.

Pamet was settled as early as 1702. They say "That your petitioner being at a great distance viz about or above twenty miles from Eastham meetinghouse built a meetinghouse of their own about five years ago for the more Convenient meeting for the Worship of God before which to wit About seven years ago they had until a month ago have had and main tained a minister or ministers which they have they allowed £45 p annum. But by reason they are not a town and consequently have no power to make assessments for the maintainance of the ministery the burden being very heavey upon such as are willing to Contribute thereto The extent of sd district is from the northerly bounds of Eastham by ye Province lands upon Cape Cod about fourteen miles in lenght & not more than 3 miles & ½ in width in ye widest place and in some parts not more than a quarter of a mile" which your petitioners humbly pray may be erected into a Township for to better government of their Civil & Ecclesiastical affairs and shall ever pray
 Tho. Pain

Sheweth
"That Pamet aforesd is a District belonging to the town and Constablrick of Eastham that in the sd District there are about forty families daily increasing Then follows the above. where marke.

Tho. Pain is called a blacksmith he was appointed to petition. Petition allowed July 14, 1709 to be called Truro.

This petition, dated "Billingsgate 1707," was directed to the Eastham town fathers to give the aforesigned Native Americans permission to found a township of their own that would become Truro. It points out that the petitioners live at "a great distance viz about or above twenty miles from Eastham meeting house." It is signed by Thomas Paine and 19 Native Americans. It concludes, "Sheweth, That Pamet aforesaid is a district belonging to the town and Constablrick of Eastham, that in the said District there are about 40 families increasing daily." The petition was granted on July 14, 1709.

These words appear on the back of the preceding petition. The notation shows the detail of a land purchase by John Freeman on behalf of the governor on February 1, 1674. The land was purchased from Native Americans Sachem Sampson of Portanimicut (an area located in what is now South Orleans), Sachem Peters, and Sachem Joshua of Pamet (now Truro). To the right of the document is a listing of the census of Native Americans: "At 'Portonimicut' or 'Nawsett' or 'Eastham' 44 praying Indians Men and Women. 24 men and women and 20 young men and maids. Of these 44, 7 can read and two can write. In 1674, Portonumecut a grant with several other places wanted 'help in a settled way.'"

When Samuel Champlain first sailed into Nauset Harbor in 1605, he drew a rough map of the area before him, showing the many Native American dwellings surrounding the inner harbor. This view shows the site of the old Doane property with the present-day marker on it.

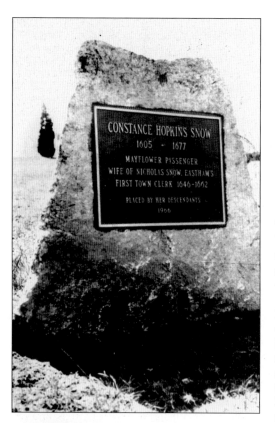

The Cove Burying Ground, which is located about a mile north of the Eastham-Orleans boundary line, is the earliest cemetery in Eastham. It holds the graves of three *Mayflower* passengers: Constance (Hopkins) Snow, her brother Giles Hopkins, and Lt. Joseph Rogers. Most of the earliest settlers of Eastham are also buried here, and many visitors in the area make the Cove Burying Ground their first stop. The first meetinghouse was north of the cemetery in the Stoney Hill area, and Rev. Samuel Treat's home was north of this property on the south side of Fort Hill.

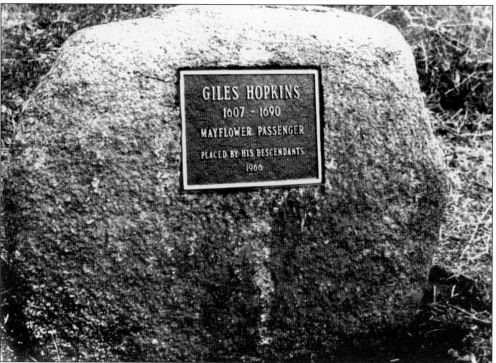

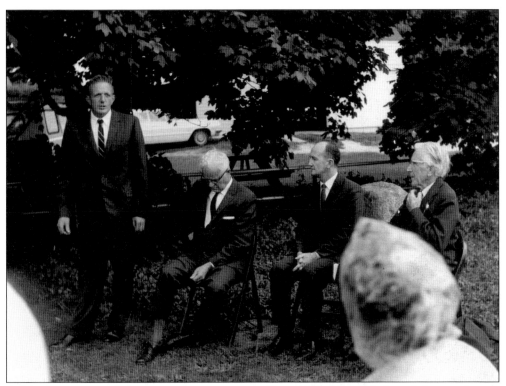

A *Mayflower* grave dedication ceremony was held in 1966. Pictured, from left to right, are Kewnelm Collins of the Eastham Historical Society, unidentified, Rev. Foster Phillips, and Dr. Robert Bartlett of the Mayflower Society.

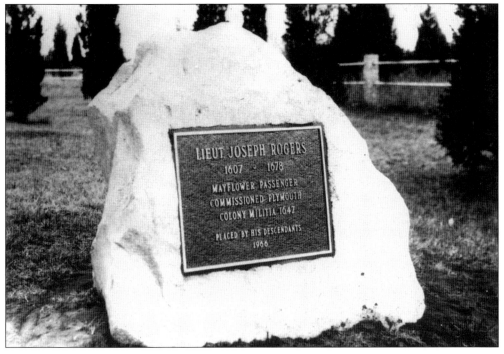

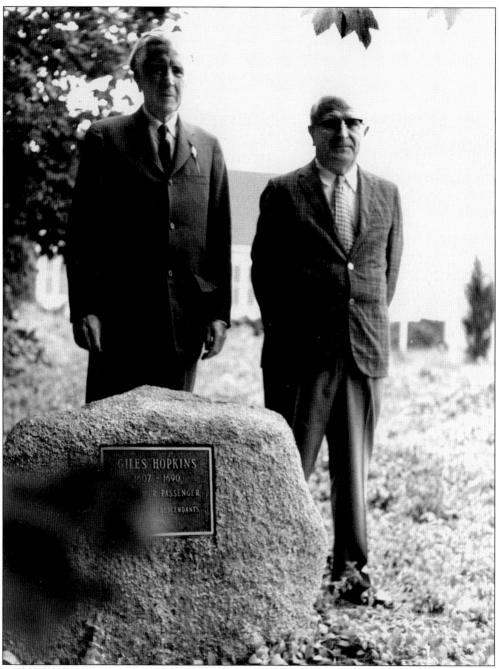

Dr. Robert Bartlett and Reuben Hopkins are posed behind the memorial stone of Hopkins's ancestor Giles Hopkins at the Cove Burying Ground.

This view south toward Orleans from the present site of Collins's cottages near the Eastham-Orleans Rotary shows the John Fenlon Walker homestead, the former home of Heman Smith, and the former Snow property, now the site of the Orleans Inn.

Looking north from the same site, this view shows, from left to right, the homesteads of Smith, Collins, and Walker. Farther on can be seen the homes of Sylvanus Lincoln and Hinckley Lincoln. To the far right is the Ryder homestead.

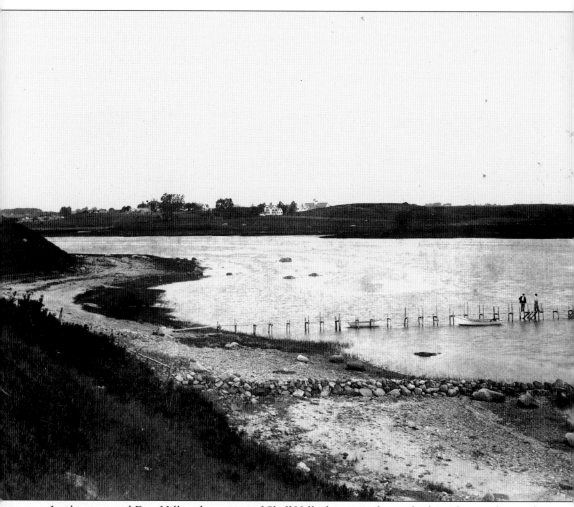

Looking toward Fort Hill and portions of Skiff Hill, this view shows the large barns of an early dairy farm. In the 1940s, the farm was owned by Charlie Gunn and was called Nauset Moors Farm. It was one of a string of farms located along the back shore. These included the Taylor farm in East Orleans, the Gunn farm in Eastham, the Horton farm in Wellfleet, the Horton and the Perry farms in Truro, and the Galeforce farm in Provincetown (owned by the Alves family). The owners worked collectively by taking turns picking up the raw milk from each farm and delivering it to the processing dairy in Marstons Mills. It is not hard to figure what caused the demise of these jewels along the sea. Each sat on prime land, open pastures with 180-degree views of dunes and ocean, all containing large tracts of land. Once demand for the land rose after World War II, these farms were no longer protected by agricultural tax relief. Instead, they were taxed as prime waterfront land.

Gone from yards all over Eastham are the wonderful windmills. This one is shown on the property of the John Smart family. The homestead was originally built by Barnabas Chipman for his daughter Abbie Chipman, who married John Smart. The Smart house, with many more ells and additions, is now the charming Overlook Inn, set across from the Cape Cod National Seashore headquarters. The sharp bleakness of the original house has been softened and today is almost entirely hidden from the road by a large glade of trees.

The foreground of this old photograph shows the icehouse that Henry Nickerson's father owned. The cottages in middle ground were called the Hatch Cottages and were built by the Springfield, Massachusetts wholesale fruit company Perkins and Hatch.

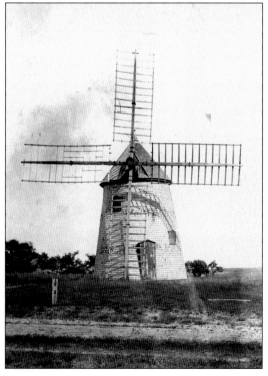

This photograph of an old mill in Eastham dates from 1882. The mill is now the center of Eastham and sits regally on the town green. It has had a long life in the history of the town. Originally, it was floated across Cape Cod Bay in pieces and located in Truro. The mill is thought to have been built c. 1790. Some documentation suggests that the pinion and vertical shaft predate 1790. The mill was allegedly built by Thomas Paine Sr., a millwright from Kent, England, who built other mills for Eastham. After the structure was moved from Truro to Eastham, its journey continued to various areas in the town as its ownership changed hands. When it was finally restored from the ground up, photographs were taken of every section of the original building, and these photographs are now in the archives of the Eastham Historical Society.

This sketch was drawn for the Village Improvement Society to support a plan for locating the library in the windmill. The first library was established over George Clark's store at the railroad depot in 1878. In 1897, William Henry Nickerson donated land to the Village Improvement Society for the purpose of building a new library.

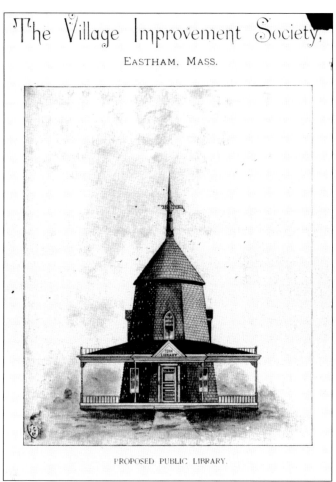

The Village Improvement Society.

EASTHAM. MASS.

PROPOSED PUBLIC LIBRARY.

The old Collins house is shown here in 1948.

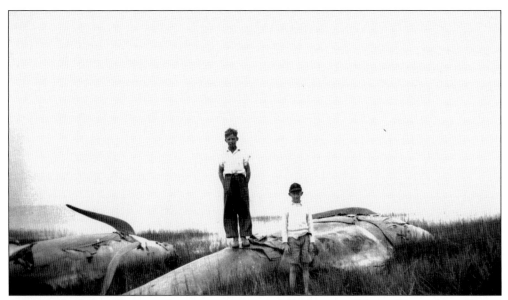

A beached whale will always draw attention, especially from small boys. Pictured are George Cowen and Robert Sparrow. Blackfish still continue to beach themselves en masse on the bayside. There are as many theories as to why they do this as there are sightings. In the old days, such events were welcome to all as gifts from the sea.

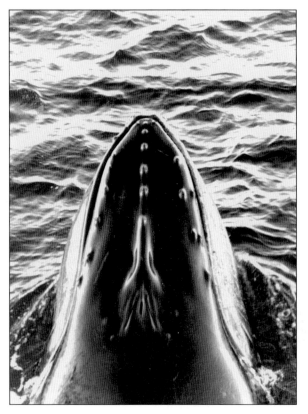

This modern view of a whale surfacing is one that is more familiar to the contemporary tourist. It shows the top of the jaw and head area of a humpback whale rising from the ocean beside the boat. For first-timers, the experience can be quite a shock. Connie (Dill) Avellar and her husband, Al Avellar, of Eastham, founded the Dolphin Fleet, which continues to take visitors to the whale grounds. (Courtesy of Marilyn C. Schofield.)

Two
LET THE FUN BEGIN

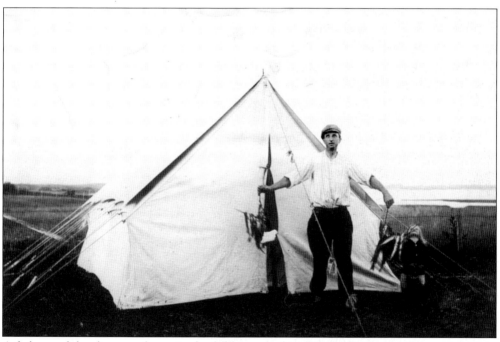

A father and daughter are shown in the fields overlooking Nauset Harbor and Nauset Marsh in the early 1900s. The strings of fish in the father's hands and the joy on the face of the girl embody the spirit of this chapter. The fence in the background appears to be more for the sake of confining pastureland than for establishing a land boundary.

This playbill is from a production of *Nobody's Baby*. The first photographed events in the field of entertainment in Eastham were a series of plays begun in the 1930s, starring the men of Eastham, Wellfleet, and Orleans. The community theatricals continue to the present day. Community theater on the Cape has reached very professional levels since the 1960s, and many new plays are penned here in the quiet days of winter, only to be produced later in New York. The actors appearing in productions across the Cape are topnotch, and the kaleidoscope of modern theater available at any given time satisfies the most sophisticated of devotees.

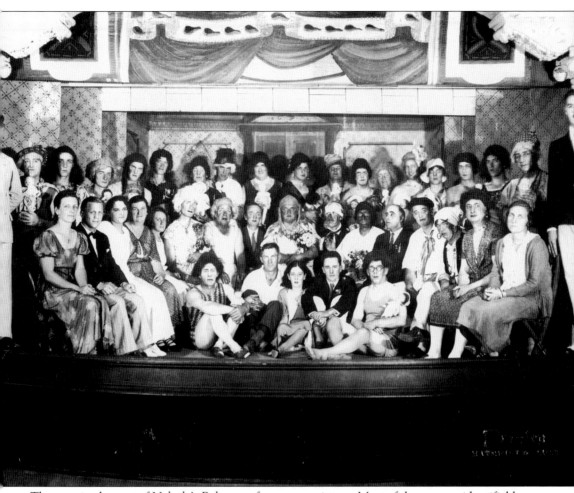

The men in the cast of *Nobody's Baby* pose for a group picture. Most of them are unidentifiable, except through photographs in the author's possession. In these, her grandmother had scratched into the images arrows and XXXs where her father, Capt. Abbott Walker, was depicted. In this photograph, Otto Nickerson is seated sixth from the left in second row. In the same row, the person second from the right appears to be a Hopkins. In the back row, the author's grandmother has scratched an inverted V above the head of her father. (Courtesy of Marilyn C. Schofield.)

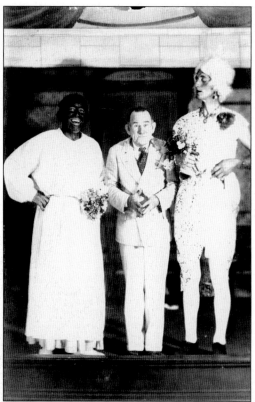

In a production of *Speaks*, the six-foot three-inch principal of the grammar school, Otto Nickerson, looks disdainfully down at a very meek-looking gentleman who may be Theodore Bird playing the character of Malvin Meekman. The man in blackface may be Warren Clark in the role of Missy.

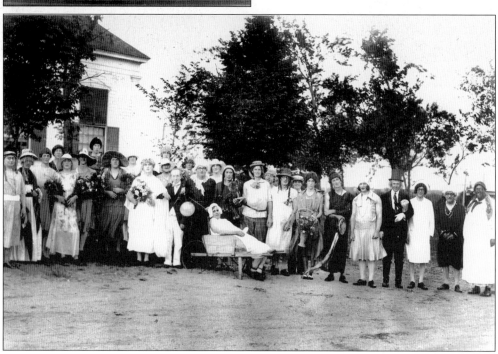

A rather unique bride and groom appear to the left of the baby in the wheelbarrow in this portrait of the cast of *The Womanless Wedding*.

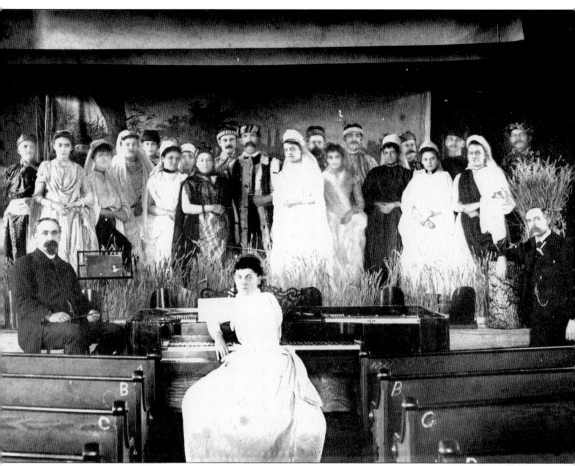

The setting here resembles a chapel interior, although on the reverse side of the photograph there is a notation: "Taken at Eastham Town Hall." Since the town hall was a center for multiple community uses, it is conjectural whether it was also used for church services.

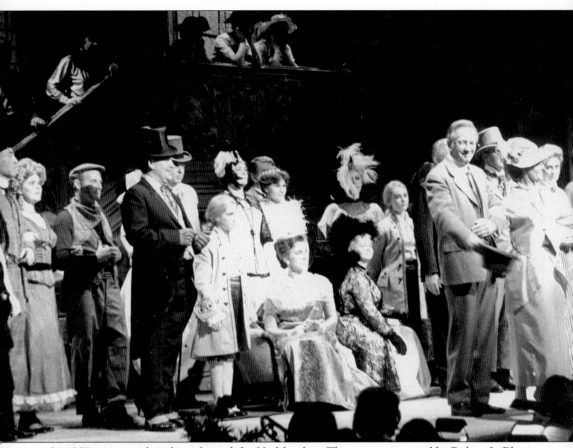

In 1958, a group of residents formed the Highlanders. They were mentored by Robert LeBlanc, a young man stationed at Camp Wellfleet, and Hazel Porch Gibson. The two of them provided guidance to the Highlanders for over a quarter of a century. All proceeds from performances were turned into scholarships for the performing arts. With Gibson at the helm of the music rehearsals, LeBlanc taught stagecraft, movement, direction, and choreography. The task was at best daunting. The raw material they had to work with was a community of fishermen, farmers, housewives, teachers, bankers, booksellers, carpenters, and plumbers—all of whom were enthusiastic but had no stage experience. Rehearsals were held at the town hall. Townspeople came to the first performance and cheered, and from there a tradition was born.

In this photograph, the cast of *My Fair Lady* takes a curtain call. From left to right are the following: (front row) Beverly Hilferty and Marilyn C. Schofield; (back row) June Bohannon, David Meade, Harold Jennings, unidentified, unidentified, Dot Wade, Pam Peters, Robert Andrews, Ken Chase, Joanne Peters, Mary Andrews, and Sally Burrill. Joanne Peters played Eliza Doolittle. (Photograph by John Schram, courtesy of Marilyn C. Schofield.)

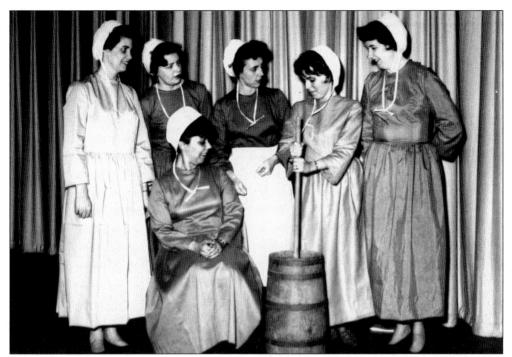

Playing a group of Amish women in the musical *Plain and Fancy* are, from left to right, Ginny Richardson, Jan Krusen, Rita Fries, Beverly Hilferty, Pam Chase, and Mary Andrews.

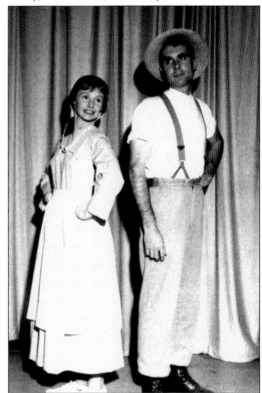

In *Plain and Fancy*, the restless Amish girl Hilda, who sings about leaving the Amish community to "sin in Lancaster," was played by Marilyn C. Schofield. Her "backwards and smittin" admirer was played by Pingree Crawford, who was a Cape Cod National Seashore ranger.

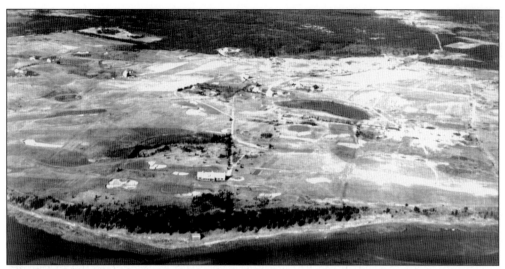

Quincy Adams Shaw of Boston arrived at his family property overlooking Nauset Marsh and Salt Pond to start a more leisurely life in 1925. He had been hospitalized for over 10 years at McLean Hospital for what was then known as a mental breakdown. His doctor had advised him to acquire a hobby and to aspire to a simpler lifestyle. Thus the idea for the Cedar Bank Links became a reality, and by 1928, the first players had teed off. Every hole had magnificent views of Nauset Marsh and the outer beach. The area surrounding it at that time was almost treeless, and it was possible to see north to Nauset Light and south all the way to the Orleans shore. One of the more unusual features of the course was the 11th hole. A player had to send the ball across the Salt Pond inlet onto the green on the other shore and then traverse to the other side by hand-hauling a flat-bottomed scow using a rope-and-pulley system. Many of the rich and famous used the links in the next two decades as Shaw's guests, including Bobby Jones and Francis Ouimet.

George W. Moore was the cook at the Cedar Bank Links for many years. In this view, he has just finished serving a large clambake to Quincy Adams Shaw's guests. The caption on the back of the photograph reads, "August 24, 1940," a date open to some speculation because the clambake was traditionally held on Labor Day weekend.

A view from the southern part of the Cedar Bank Links reveals the houses across the little inlet that separates the two sections of the golf course. The entrance to Salt Pond can be seen on the extreme right.

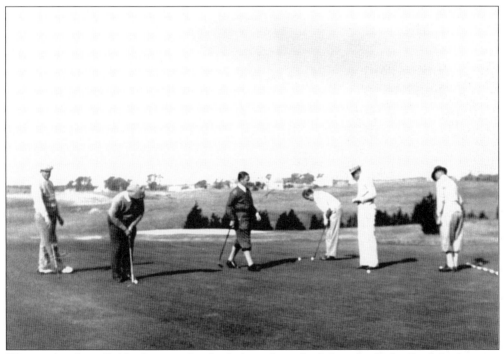

Wearing knickers, Bobby Jones is the third player from the left at the Cedar Bank Links.

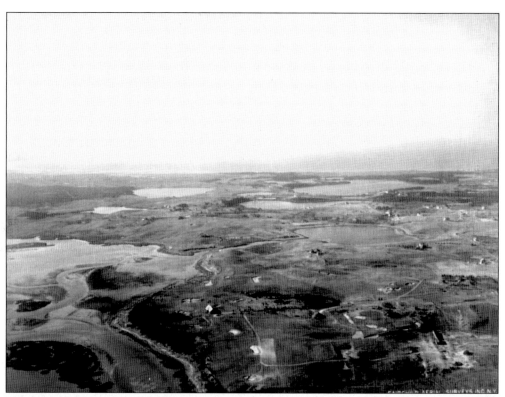

This view of the south section of the Cedar Bank Links clearly shows the two sections separated by the inlet leading into Salt Pond. When players had to go to the southern section of the links, they did so in a flat-bottomed scow.

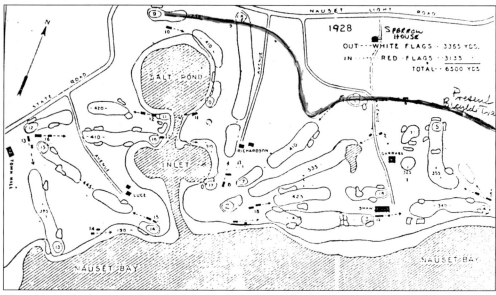

This is an early diagram of the 18-hole Cedar Bank Links.

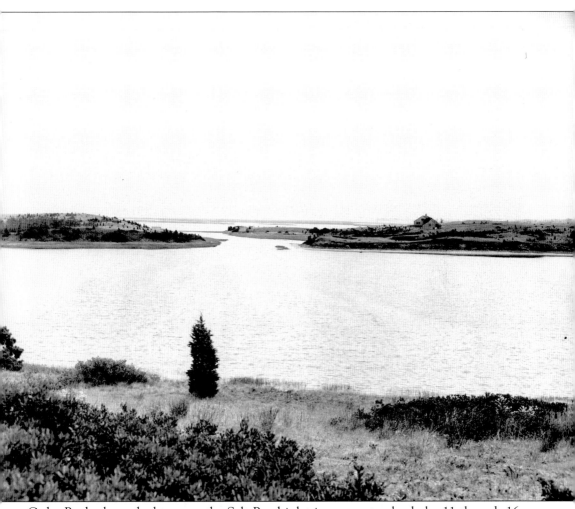

Cedar Bank players had to cross the Salt Pond inlet in a scow to play holes 11 through 16, before crossing once more to play out hole 17. This 1930s photograph shows the same view that visitors now see from the Cape Cod National Seashore Visitor Center. Gone, however, are those wide panoramic vistas of earlier times. Now the area is covered with dense stands of cedar, pitch pine, and locust. While environmentalists welcome the growth, many of the old-time natives of Eastham have long considered them "weed" trees. Recently, the Cape Cod National Seashore personnel have begun to address the problem of "invasive plant species" and the impact on local native plant species.

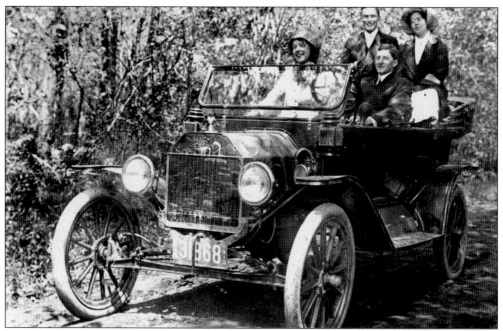

Oh, those lovely machines! Shown here are Katherine Beaton and Roscoe Taft in the front seat and Verena Springer and Raymond Daley in the back. Springer went on to become Mrs. Daley, but Beaton later married Maurice Moore.

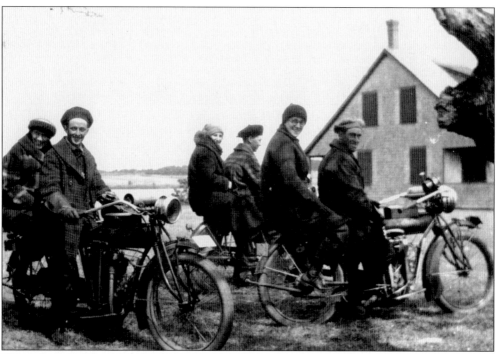

These three couples are dressed for a Sunday afternoon ride. Seated on the bicycle to the right are Henry and Dot Clark.

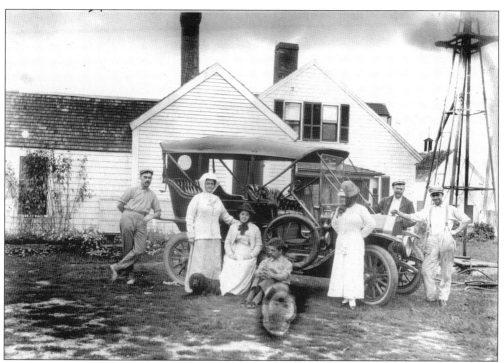

This photograph was taken on a Sunday afternoon in Eastham *c*. 1910.

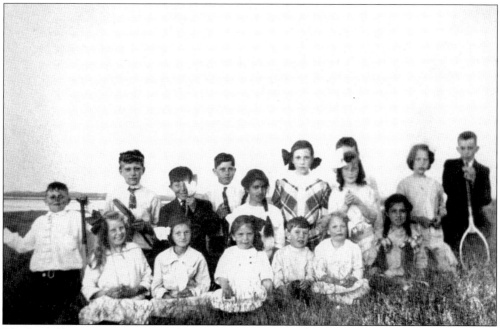

The Luce home was situated on the southern part of the Cedar Bank Links. Pictured here at a birthday party in 1904 are, from left to right, the following: (front row) Alice Luce, Phylys James, Margaret Dill, Alton Crosby, Althea Bangs, and Ruth Babash; (back row) Gordon Braendle, Maurice Moore, Livingston MacPherson, Bernard Crosby, Anna Habash, Doris Penniman, Muriel Pennimen, Mathew Luce Jr., Elinor Griffin, and Herman Dill.

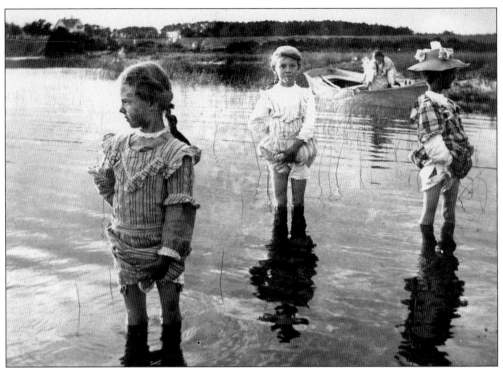

These little wading girls capture the innocence of an earlier time in Eastham. Although their pantaloons and ruffles are cumbersome, they appear to have overcome the obstacle quite handily. Note the very short hair on the little girl on the right. In the background, a girl (possibly a big sister) is cavorting in a boat.

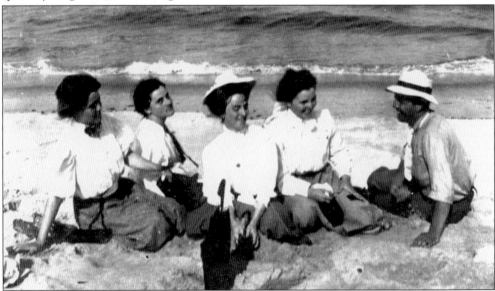

Eastham is fortunate to have the ocean to the east and Cape Cod Bay to the west, as well as many clear freshwater ponds. No history about the town could be complete without showing its inhabitants enjoying this world of water. This group photograph taken on Nauset Beach in 1908 has a caption on the back that reads, "Christine, Celia, Ada, Tidda and George. Lucky George!"

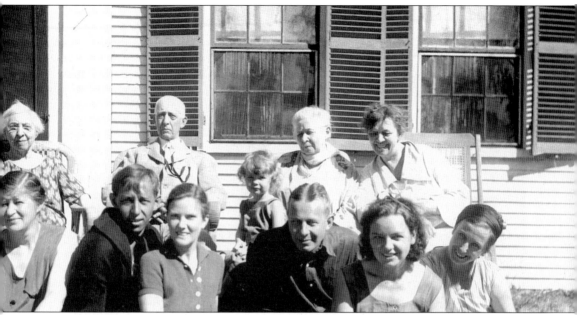

The Sunday afternoon family gathering was a favorite pastime. Family members posed in front of the Clark-Hatch House on Samoset Road in 1934 are, from left to right, as follows: (front row) the cook; Philip J. Schwind; his wife, Helen Schwind; Walter M. Hatch Jr.; his wife, Madeline Hatch; and the children's nurse; (back row) Paulina Brackett Hatch; her brother-in-law Walter Maynard Hatch; his great-granddaughter Paula Maynard Schwind; his wife, Susan Foster Hatch; and their daughter Eugenia Schwind Merrill. Philip Schwind lived all of his life on Samoset Road and later became the shellfish warden of Eastham.

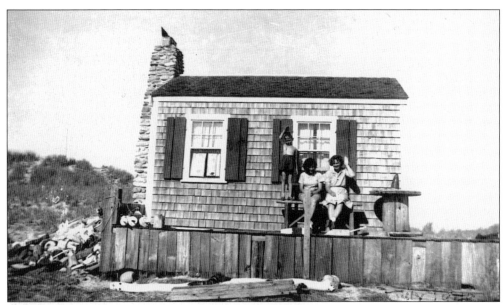

The Dill family beach shack is shown as it appeared on Nauset Beach nestled in the dunes. Today it is lovingly preserved.

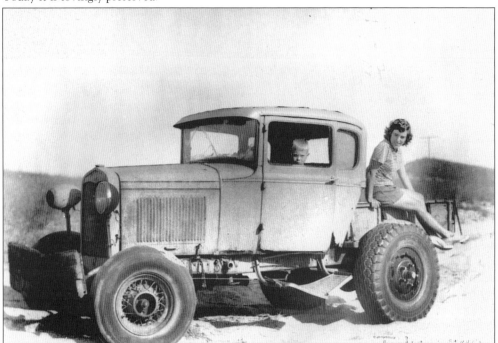

A beach buggy had to have a light tire tread, and air was let out of each tire until it had between 15 and 20 pounds of pressure in order for the vehicle to travel on sand. Jay Schofield remembers being on the school committee for a summer in the 1950s, when they were planning the regional high school that would be built on Cable Road. The project entailed many meetings, and committee members traveled down the old beach road in their buggies, where meetings were held in Betty and Jen Collins's beach shack. Schofield said that the piping of the shore birds and the lamplight mellowed everyone, and disagreements were not prevalent that summer.

Along the length of Nauset Beach from the Coast Guard station south was a string of beach shacks. They were unique in architectural detail, sometimes humorous, and all had a romance about them. The shacks were lit by kerosene lamps and were without any form of electricity. Visitors endured nighttime treks to adjacent outhouses. The shacks were used by families, hermits, duck hunters, and writers. Erosion and storms managed to destroy all but one. Through the generosity of Tom Dill of Eastham (pictured here with his dog Sally in 1952), the Dill cottage was moved to the site of the Swift-Daley Museum complex. The homestead, beach camp, and tool museum are open in the summer months.

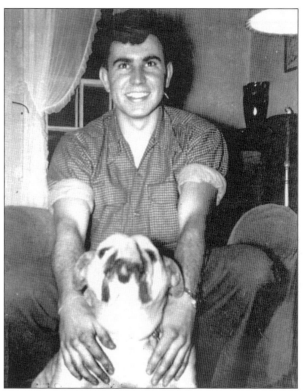

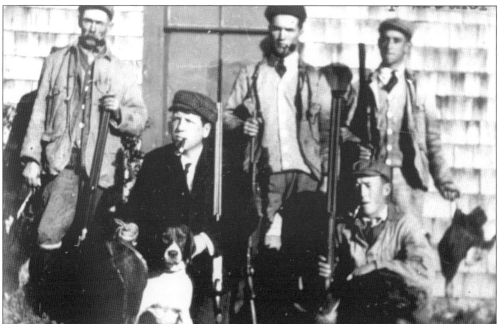

Members of the Chase family of Eastham are shown after a successful hunting trip with their faithful bird dog. The photograph was captioned by Ralph Chase as follows: "My father and two brothers and step brother. The senior Chase is located on the left, others named are Leroy Chase, C. Elwood Chase and ——— Brewer.

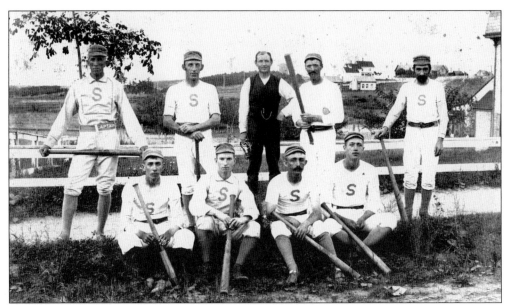

Sports had became a big part of life in Eastham and the lower Cape by the early 20th century, but few photographic records of group athletic activities were made. One reason might be that by the time the Great Depression hit, residents faced many economic hardships. Sports were free and fun, but cameras and film were definitely a luxury. This adult baseball team sporting the uniform of Snow's Store in Orleans was made up of men from Orleans as well as Eastham. By the time this group of Eastham young men posed for the photograph below, probably in the late 1950s, organized sports for youngsters came into being with Little League teams. Today old-timers still assert that sandlot baseball was the best teacher of life, bar none. (Courtesy of Marilyn C. Schofield.)

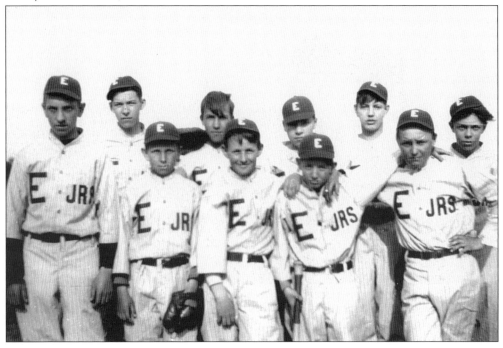

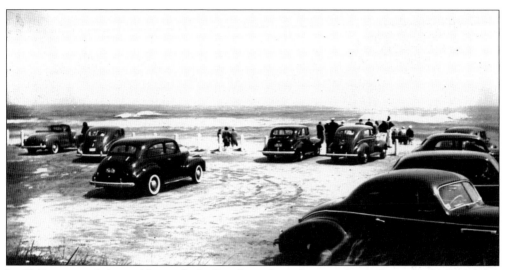

In 1940, a typical day at Nauset Light Beach, such as the one shown here, would have been characterized as a traffic jam. It is hard to believe that now sometimes more than 600 cars come and go in a day.

A bevy of beauties sits on the landing at the beach cottage named Lowestoft. From left to right are Helen Lawton, Juliette Perry, Bernice Moore, Esther Moore, and Matilda Smart (with a pistol in her belt). The caption on the back of the photograph reads, "Matilda always took the pistol in case of pirates."

No beach outfit would be complete without hats such as the one worn by this charming beach lass of 1904.

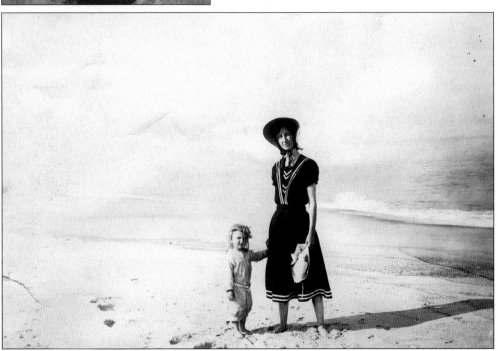

This mother with her child models the beach fashion of the time. There is something poignant in the face of the mother, and the solitude of the beach behind the little family makes a perfect composition.

Three

SCHOOL DAYS

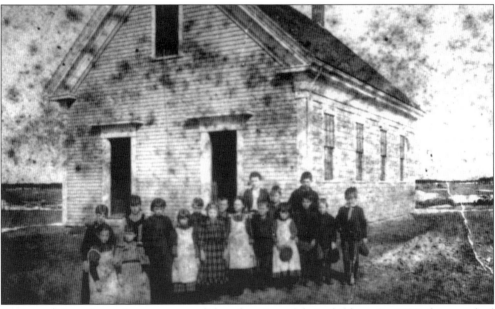

Eastham citizens have always supported the education of their children. By 1687, the town had appropriated money to hire a tutor to teach in private homes. In 1687, the General Court of the Plymouth Colony ordered all towns of 50 families or more to employ a teacher. It laid a duty on all fish caught in the colony, and an annual sum of 50 pounds was given to each town to support its schools. In 1697, Eastham built its first schoolhouse. As the population increased over the years, five schools were built, but by 1902, the population had decreased and only one school was needed. Two of the five schools were moved to the present location and added to the one-room schoolhouse already there. The other two school buildings were sold to private owners. The buildings were placed together in a T shape, and the three-room Eastham Grammar School was born. It served Eastham's children until 1936, when a new elementary school was built. Over the years, the two wings were also sold and moved from the site. In the 1980s, the Eastham Historical Society purchased and restored the long neglected building. Today it stands ready to greet the public as the Schoolhouse Museum.

Otto Nickerson was a beloved teacher and principal at Eastham Grammar School and Eastham Elementary School. A graduate of the normal school in Hyannis, he began his career as a teaching principal in Eastham in 1918. The lure of the city took him away for three years, but when he received a letter from the Eastham school board offering him his position back, he came back to Eastham. He bought a house and married Albina Brewer (of the Eastham Brewers), with whom he raised two children. His career as an Eastham educator spanned 38 years, and he became one of the town's most respected citizens.

The Eastham Grammar School is shown in 1941.

These young people are part of the eighth-grade graduating class of the Eastham Grammar School of 1900. Are they really shyly comparing medals or is something more important going on here?

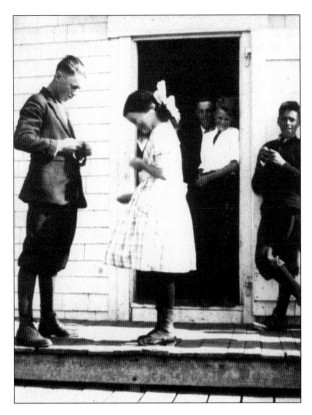

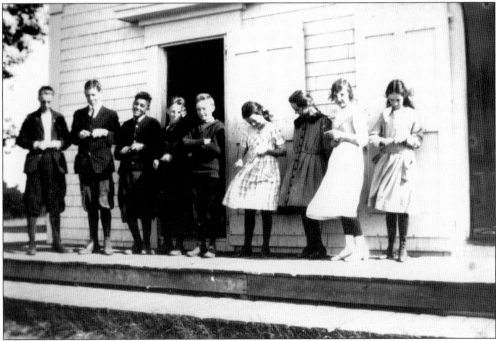

Although a little reluctant about posing for the camera, these members of the same graduating class as above seem proud of their achievements as they stand here in their Sunday best.

Eastham Grammar School's sixth, seventh, and eighth grades are pictured in a series of photographs from May 29, 1917. From left to right are the following: (top row) Mr. Burgess, Cynthia Ellis, Anna Habsh, Evelyn Mayo, Lewis Collins, Sadie Chase, Ruth Habash, and Carl Gross; (second row) Mildred Horton, Earland Rummels, Herman Dill, Myra Horton, Sam Brackett, Ruth Kelly, Wilton Hopkins, and Charles Brown; (third row) Carrol Gross, Evelyn Daniels, Mildred Kelley, Emily Daniels, Effie Souza, Della Knowles, George Tompson, and Gertrude Ryder; (bottom row) William Runnele, Esther Sparrow, Virginia Nickerson, Nathan Nickerson, Sidney Horton, Minnie Gill, Abbott Knowles, and Malcolm Steele. (Courtesy of Della Knowles Macomber.)

First-day-of-school finery is modeled by, from left to right, Eleanor Knowles, Olive Clark, Florence Whidden, Ed Clark, Vernon Nickerson, and Wesley Moore.

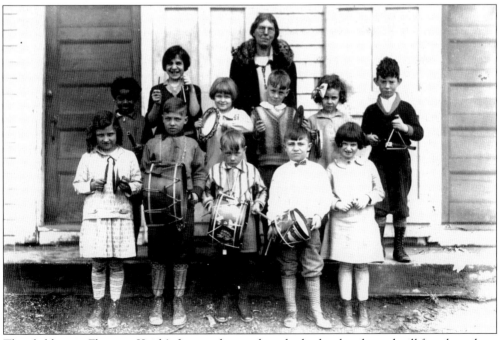

The children in Florence Keith's first- and second-grade rhythm band stand still for a beat, long enough for this photograph to have been snapped. They are, from left to right, as follows: (front row) Hazel Fulcher, Robert Fulcher, Bob Collins, Charlie Meads, and Florence Cox; (back row) unidentified, unidentified, Leona Gunn, Malcolm Murphy, Hope Hurd, and Irving Lee.

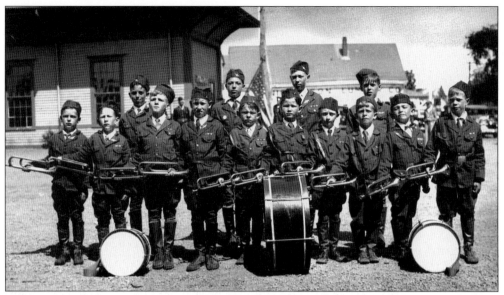

This group of small boys that made up the Eastham Drum and Bugle Corps was the pride of Eastham parents. They are, from left to right, as follows: (front row) Bob Pearson, Charlie Twood, Genton Sparrow, Brad Steele, Nate Nickerson, Bill Watson, Bob Brewer, Bob Scrivens, Dick Brewer, and Ken Mayo; (back row) Whit Howes, Robert Fulcher, Carleton Mayo, and Don Sparow.

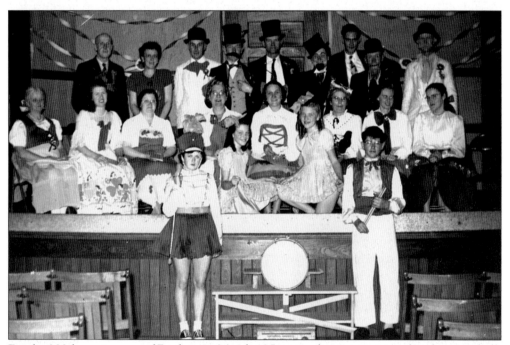

For the 300th anniversary of Eastham in March 1951, a production was staged at the town hall. Note the shamrocks on some of the skirts worn by the women. Standing in front are Norma (Clark) Mead and her brother John Clark. At stagefront are the Johnson sisters.

A small group gathers on the last day before their graduation from Eastham Elementary School. They are, from left to right, Joe Vogel, unidentified, Marie Tibbals, Norma Mead, Connie Dill, unidentified, and unidentified.

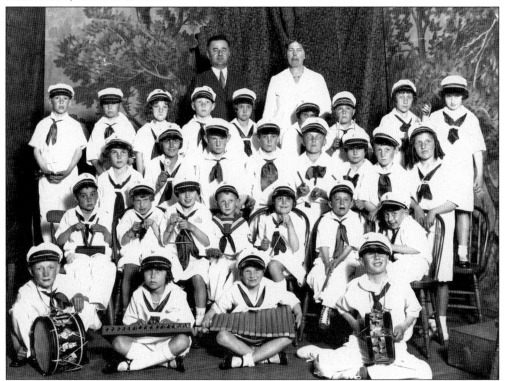

The 1934 Children's Musical at Eastham Grammar School was directed by teachers Thomas G. Nassi and Florence Keith.

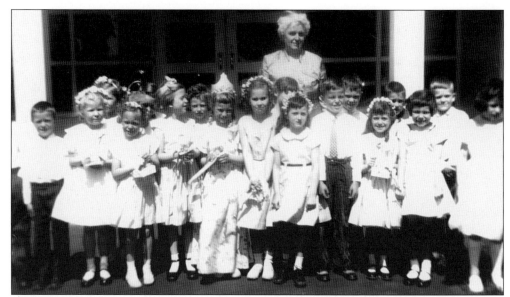

Teacher Vesta Gould and her class are dressed for a May Day celebration on this bright sunny day in the 1950s. The Queen of the May wears a special crown. Each of the other girls has flowers in her hair and is poised to offer her May basket to give to the boy of her choice, if she can catch him.

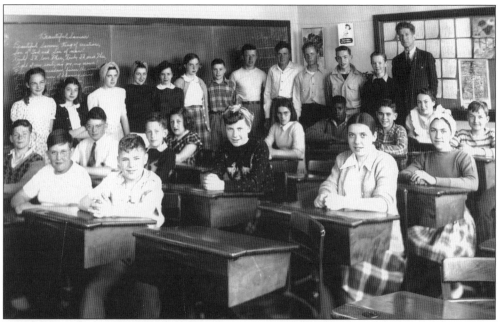

Eastham Elementary School principal and teacher Otto Nickerson stands with his class in the late 1940s. Those at their desks are identified as Donald Emond, Jack Ohman, John Clark, Charlie Wiley, Peter Walker, Diane Day, Priscilla Lincoln, Allan Macullough, Beverly Shaklis, ? Doughty, Neal Rogers, Sharon Travers, and Ted Tibbles. Standing are ? Tibbles, Betty Newcomber, unidentified, Betty Doughty, Nancy Schofield, Janet Gould, unidentified, Donald Ohman, Bob Whiting, unidentified, and "Sonny" Manard Walker.

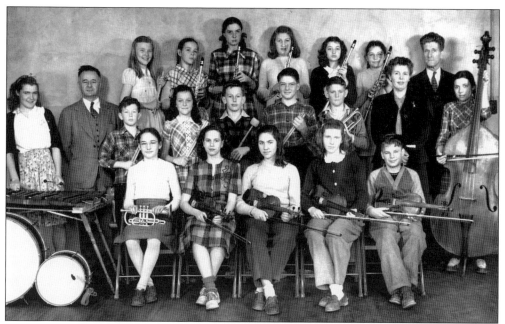

Music played an important role at the Eastham Elementary School during the 1930s and 1940s, after Thomas G. Nassi and his wife, Olympia, introduced instrumental music instruction there. They offered an enriched musical program to youngsters in this rural setting. The youngsters in the Eastham Elementary School Orchestra are captured here with their principal Otto Nickerson and their teachers Thomas G. Nassi and Olympia. From left to right are the following: (front row) Esther Tibbals, Nancy Schofield, Sharon Tarvers, Priscilla Lincoln, and Charlie Wiley; (middle row) Edith Emond, Thomas Nassi, unidentified, Betty Johnson, Peter Walker, John Clark, Donald Edmond, Olympia Nassi, Beverly Shalkiks; (back row) ? Johnson, Judy Colins, Janet Gould, Diane Pierce, Betty Macomber, Helen Edmond, and Otto Nickerson.

A Woody station wagon sits parked near the Eastham Elementary School in the early 1950s.

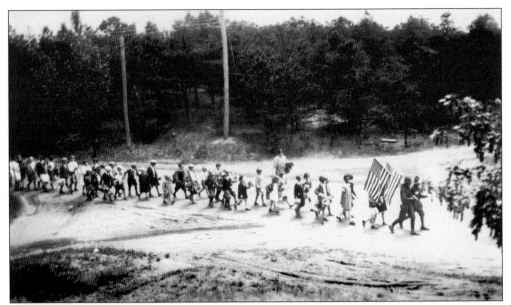

Otto Nickerson began a tradition that continues today when he led Eastham schoolchildren, shown here in 1931, to the cemetery after the signing of the armistice that ended World War I.

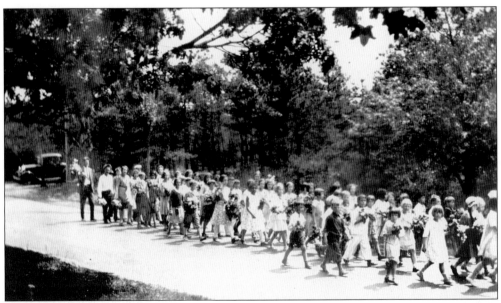

Since that first year, the whole community joins a walk every Memorial Day to lay flowers on the graves of veterans and loved ones. There has been one change since this picture was taken in 1931; now the children also lay flowers on the grave of Otto Nickerson.

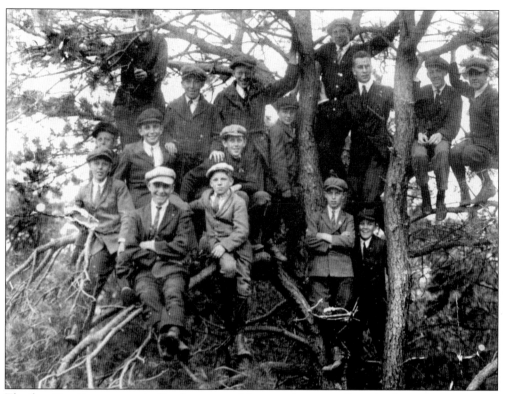

The first Boy Scout troop in Eastham poses 16-strong in a tree. Even in shirts, ties, suits, and hats, they seem at home.

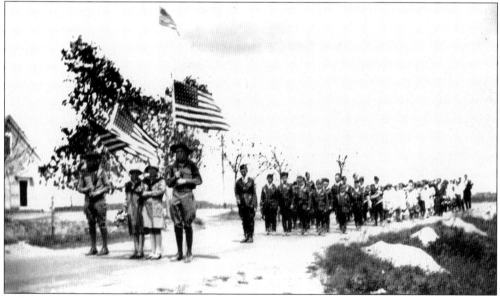

A later Boy Scout troop leads Eastham schoolchildren in the Memorial Day parade to the cemetery.

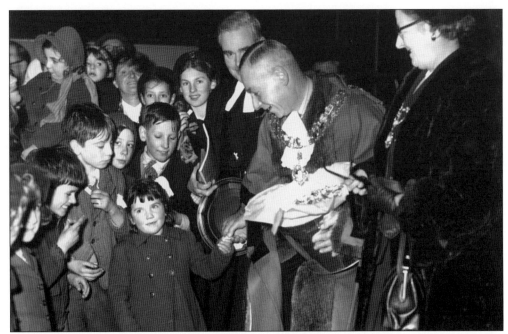

The mayor and mayoress of East Ham, England, Alderman and Mrs. Hurford, and Rev. J.O. Nicholls, vicar of East Ham, distributed candies sent from children in Eastham, Massachusetts, to English children at East Ham Town Hall. In 1951, the children of the Cape Cod Eastham sent a shipment of candies to children in East Ham, England, who had suffered severely during the bombing of London in World War II. In 1944, the children of the Methodist church in Eastham had sent a scrapbook to the children of East Ham, England, describing life in their community. In turn, their counterparts in England sent a scrapbook to the children here. Now kept in the Eastham Public Library, the scrapbook is full of essays, poems, photographs, and artwork that capture the lives of these English children during World War II and their hopes for the future.

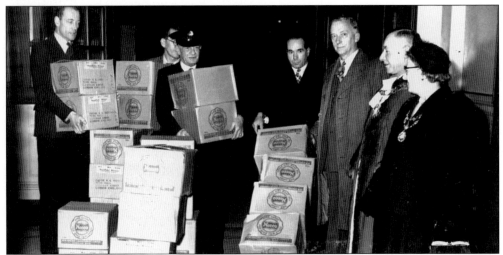

The mayor and mayoress of East Ham and W. Starnes of the *Stratford Express*, are watching the unloading of the gift of the American candies at East Ham Town Hall, East Ham, England, on December 18, 1951.

Four

LIFESAVERS AND OTHER BRAVE MEN

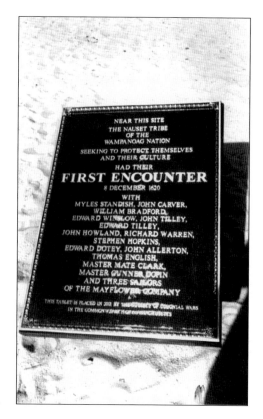

This plaque was erected at First Encounter Beach in Eastham in commemoration of the Pilgrims and Native Americans of the Wampanoag tribe by the Society of Colonial Wars in the Commonwealth of Massachusetts.

Commonwealth of Massachusetts.

OFFICE OF THE SECRETARY.

REVOLUTIONARY WAR SERVICE
OF
Hezekiah Rogers

Hezekiah Rogers: Appears with rank of *Sergeant* on Muster and Pay Roll of Capt. Benjamin Godfrey's co., Col. John Cushing's regt. Enlisted Sept. 25, 1776. Discharged Nov. 23, 1776. Service, 1 mo. 29 days, at Rhode Island. Roll dated Newport.

Vol. 21: 67.

Hezekiah Rogers: Appears with rank of *Private* on Muster and Pay Roll of Capt. Benjamin Godfrey's co., Col. Josiah Whitney's regt. Enlisted May 10, 1777. Discharged July 10, 1777. Service, 2 mos. 12 days. Residence, Eastham. Company stationed at South Kingston, R. I. Roll dated Boston Neck.

Vol. 2: 66.

The original document of the service record of Eastham's Hezekiah Rogers indicates that he rose to the rank of sergeant before being mustered out. He served in Capt. Benjamin Godfrey's company and in the regiment of Col. John Cushings. He later served twice in Capt. Joshua Higgins's company, first under Maj. Zenas Winslow's regiment and then Col. Josiah Whitney's regiment.

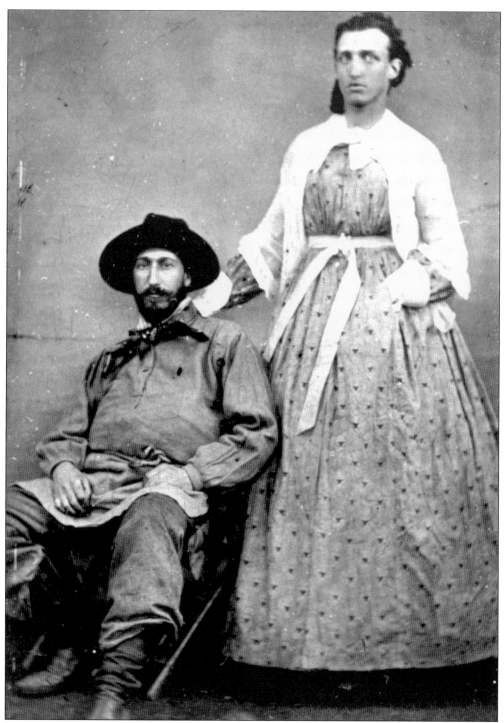

This photograph was found among the possessions of Eastham Civil War veteran Atkins Higgins. It depicts a Civil War camp theatrical skit. A collection of Higgins's photographs is now kept at the Schoolhouse Museum, one of two museums owned by the Eastham Historical Society.

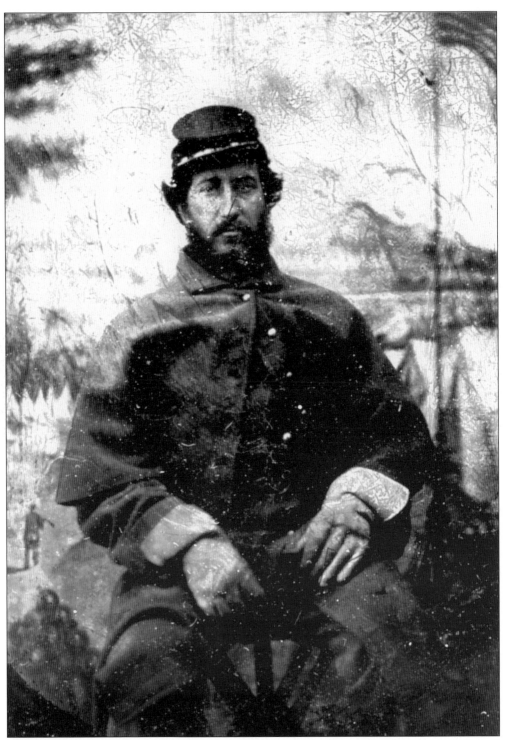

This formal photograph of Atkins Higgins of Eastham was taken with the traditional painted background of the photographer. These portraits were popular during the Civil War, when the camera finally gave us a pictorial history of men at ease and in battle.

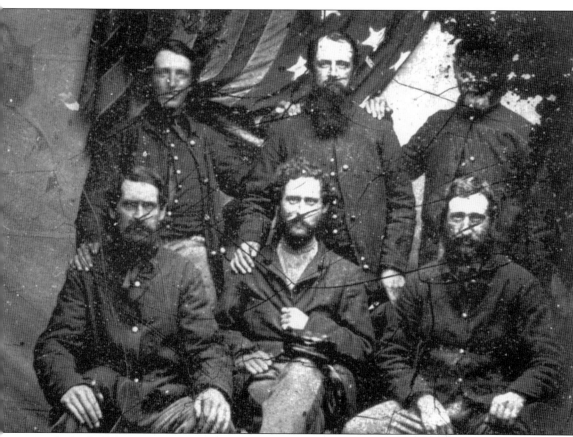

On the back of this photograph of unidentified Civil War soldiers is a notation that it was found with Atkins Higgins's other memorabilia. The following is a complete list of the men from Eastham who served.

Atkins Higgins of Eastham was one of 52 men from Eastham who served in the Civil War. The others were Alonzo Bearse, Erastus Hallen, George Broek, Charles A. Hatch, James Banks, John Lister, John Brown, Henry T. Morrison, George Collins, Patrick McNamara, James G. Connell, John P. McLane, John Clark, Samuel Nickerson Jr., John S. Chase, John Nicholson, Thomas Carmody, Francis W. Penninman, George Colby, John Riley, John Caligan, James Ronney, Michael Cunin, Henry Roberts, Albert F. Dill, Samuel Snow, Alvin L.Drown, Dennis Sullivan, Peter Dyan, Elkanah E. Smith, Edward Foss, James W. Smith, Stephen Foster, Reuben E. Smith, Nathan A. Gill Jr., Sylvester Shea, Albert Granville, Ira Smith, John A. Greene, Matthew Thompson, Daniel P. Hopkins, Charles O'Toole, William M. Hopkins, Louis Vasconi, Charles M. Horton, Henry H. West, Peter Higgins, Edward Young, John Hall William, J.H. Yates, and John Hennessey.

Atkins Higgins served with the U.S. Engineers, which had a camp at Rappahannock Station.

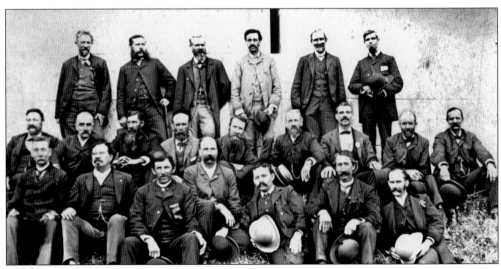
Ten years later, on August 25, 1886, the engineers who served in the Civil War held a reunion at Fort Independence. Atkins Higgins is shown second from the right in the first row.

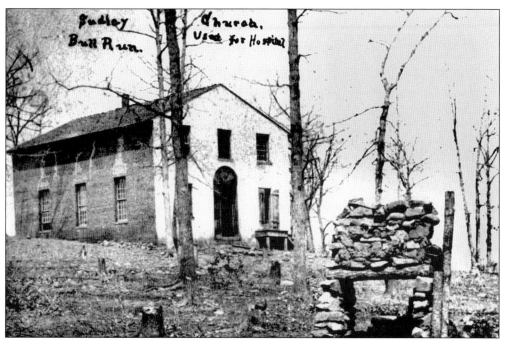

Here is an example of another photograph found with Higgins's collection.

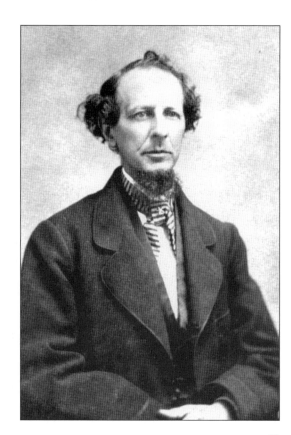

Atkins Higgins is portrayed as he appeared later in his life.

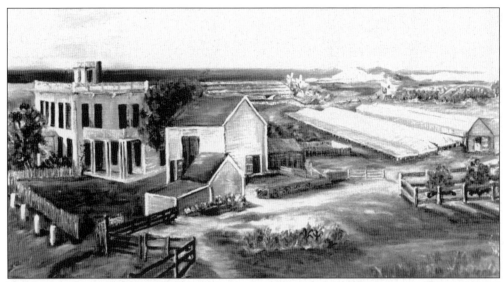

This painting is attributed to the work of two men: Capt. Jonathan Sherman and Capt. Samuel Freeman. To further add to the confusion, a copy of the original painting was made by a Viola Wright. The painting was presented to the Eastham Public Library by Anna Hoyt Mavor on September 12, 1977. The view clearly shows the saltworks behind the homestead. The house, on Bridge Road, was known as the Jonathan Sherman house and was built *c.* 1770 by Thomas Knowles.

Barnabus Higgins Chipman (1928–1874) was a coastal schooner captain and owner of the vessel *J.C. Wellington.* He transported lumber from Wellfleet aboard the *Wellington* to Eastham, where he built the Carriage House at the Overlook and other Eastham buildings.

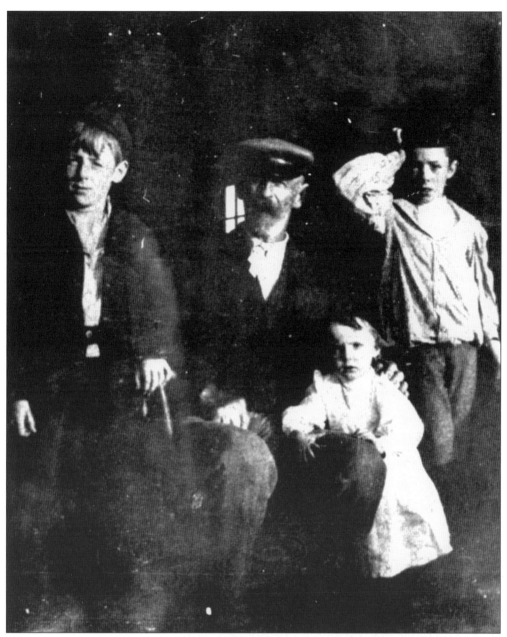

Almost every Eastham family had men who went to sea in one way or another. This photograph shows John Fenlon Walker (home again and living on the shore of the cove) with three of his grandsons. At the left is Lawrence Walker, son of Capt. Abbott Walker. Lawrence died shortly after this picture was taken. He was coming into Chatham when he suffered a ruptured appendix. Taken to a nearby house, he died there. On the right are the sons of Lawrence Walker's daughter Celia Crosby. Gerard Crosby is at his grandfather's knee, and Kenneth Crosby is standing. Their father, Orville Crosby (a stonecutter by trade), was the grandson of Joshua Crosby, who served so well on the USS *Constitution*. When he was 32 years old, "little" Gerard Crosby became the youngest captain ever of a Holland American Steamship Line vessel.

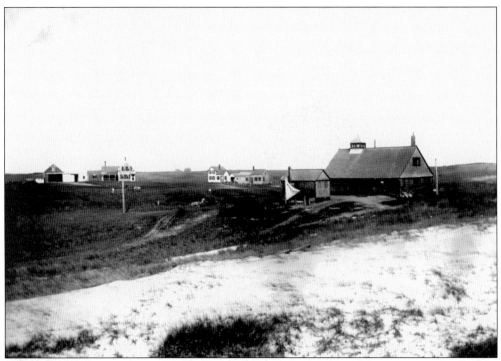

This photograph of the Nauset lifesaving station shows the building's natural siding, beautifully weathered from storms.

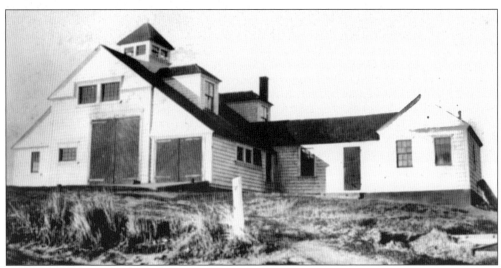

In 1905, the U.S. Life-Saving Service and the Coast Guard merged, and buildings took on the characteristic white siding and red roofs typical of all Coast Guard buildings, such as the newly painted Nauset lifesaving station, which appears here as Coast Guard Station No. 39.

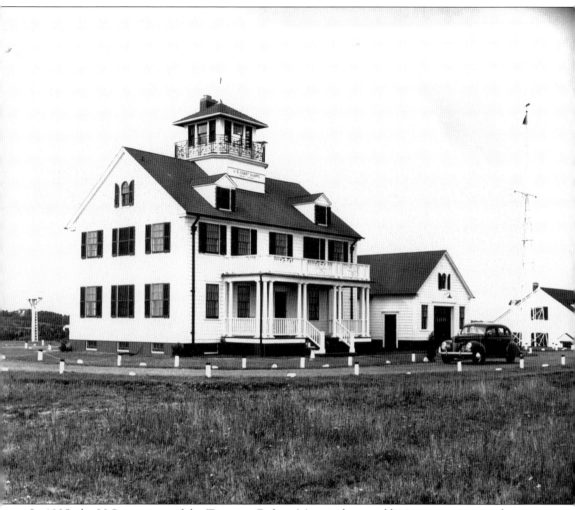

In 1935, the U.S. secretary of the Treasury, Robert Morgenthau, and his guests were picnicking on the beach near the Coast Guard station. A fast-moving thunderstorm forced the party to seek refuge at the station. With the characteristic hospitality of the Coast Guard, they welcomed in the picnickers and gave them the run of the galley. Only later (when Morgenthau asked to tour the building) did the Coast Guard station chief realize who his distinguished guest was. At the time, Nauset Station was one of the oldest stations in existence. Within weeks of the Treasury secretary's visit, the men of the station received a letter from Washington, D.C., announcing that it would be replaced with a new, modern station.

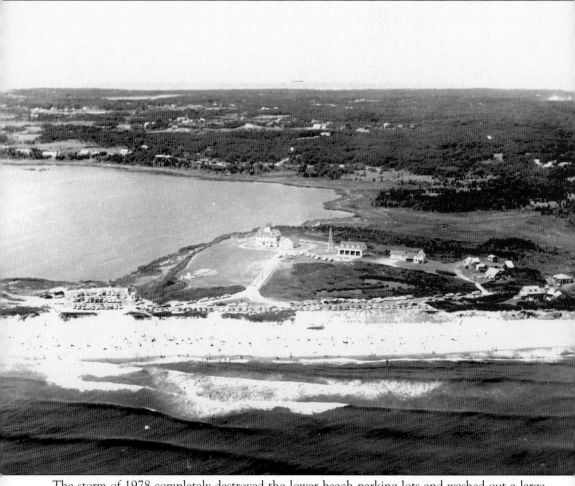

The storm of 1978 completely destroyed the lower beach parking lots and washed out a large bathhouse. Erosion continued through the next few years, and after one particularly strong autumn nor'easter, the pond in the wooded triangle (shown in front of the boathouse here) was undermined and breached. As the supporting banks gave way and the fresh water from the pond flowed to the sea, a slice of time was revealed in the layers of sediment exposed. It took a young man named Carns, who was walking the beach with his children, to realize that much more had been exposed than mere sediment layers. He recognized with excitement that an ancient fire pit had been uncovered. Archeologists were called in to catalog the relics and artifacts at the site as fast as they could. The approaching winter tides and storms gave them only a few weeks to work before the site would once again be underwater and washing out to sea. As the scientists left the site for the last time, they conservatively estimated the fire pit encampment to have existed 7,000 years ago.

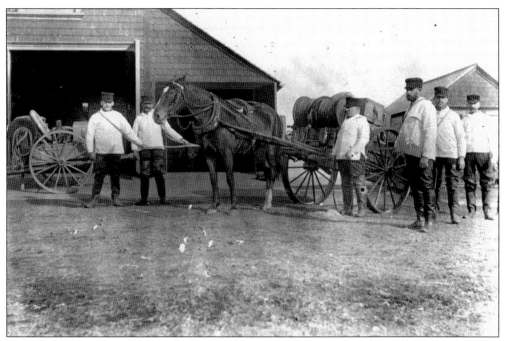

The full lifesaving station complement with its apparatus wagon and men dressed in summer uniforms is on display in this lineup. Capt. Abbott Walker is on the left. Next to him is the number-one surfman, generally next in line should anything happen to the keeper. On the right are the rest of the members of the seven-man crew in order of their seniority. (Courtesy of Marilyn C. Schofield.)

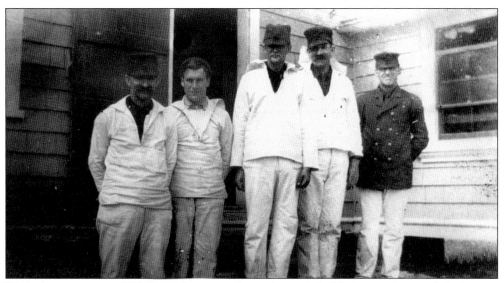

With the exception of Walker, who wears the traditional double-breasted coat of the keeper, the lifesaving station crew is caught in a casual moment.

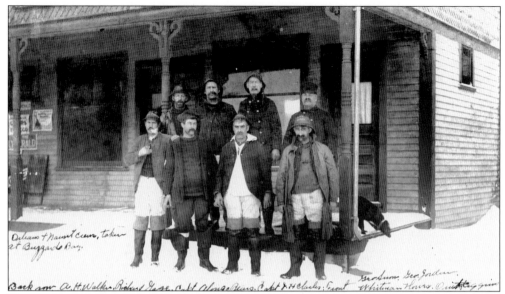

The combined lifesaving crew of the Orleans and Nauset Stations are gathered at Buzzards Bay. From left to right are the following: (front row) George Snow, Grover Jordan, Whit Howes, and Orin Higgins; (back row) Abbott Walker, Richard Gage, Capt. Alonzo Bearse, and James Charles. (Courtesy of Marilyn C. Schofield.)

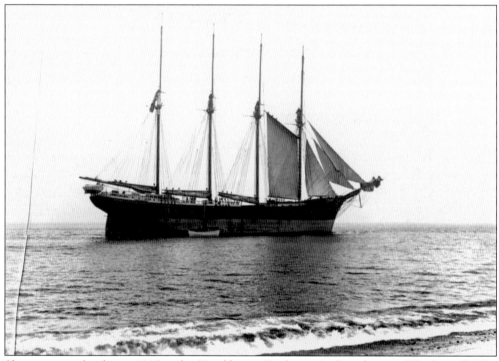

Shown on a calm day in 1895 is the *Haroldine* at Eastham. At first glance, all looks well. The *Haroldine*, however, is in a place most mariners would dread. It sits high in the water on the inshore side of the treacherous "outer bar," but its appearance indicates that it probably survived well the circumstances that put it there.

Name of Bark*Italian Castagna*.....

Where From*Genoa*.....

Loaded with*Fertilizer*.....

Date came ashore*February 17th 1914*.....

How many rescued*Eight*.....

Were any drowned*Captain and Cabin boy*..... *Frozen to death Cook and one sailor*

Did she break up at once*2 day after stranding there came a sever Eastly storm and she broke up and went to pices*

Tonnage*four thousand tons*.....

Age*40 years*.....

REMARKS :-

The bark came a shore in a thick snow storm in a gale of wind and Temperature down to 14, freezing every drop of water that hit her she looked like a ice burg when we arived on the spot. we sent two life lines on board but the men being so crazy with fight they through the lines overboard. when the wind and sea had moderated we get along side with boat and took off the remaining crew. the Captain and cabin boy dropped out of the rigging into the sea. and were lost. the Captain was found one year after in Nauset harbor by a gunner the body had been buried under the sand and Kept so he could be recognized by his clothes he had on Capt Abbott H Walker

The report filed on the wreck of the Italian bark *Castagna* describes the tragedy: "The bark came ashore in a thick snowstorm in a gale of wind and temperature down to 14 degrees, freezing every drop that hit her. . . . We sent tow life lines on board but the men being so crazy with fright threw them overboard. . . . When the wind and sea moderated a bit, we got the boat alongside and took off remaining crew. The Captain and Cabin boy dropped out of the rigging and were lost. Respectfully, Capt. Abbott Walker C.G. Sta. #39 Eastham."

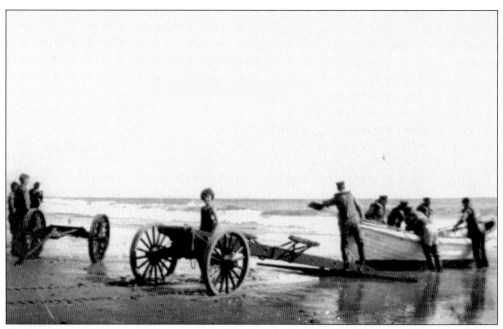

Bathers watch the lifesaving station crew at the beach during unloading and launching practice in August 1924.

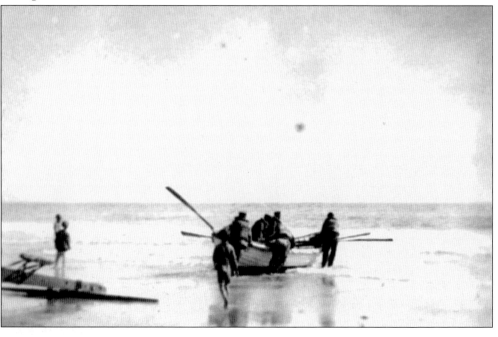

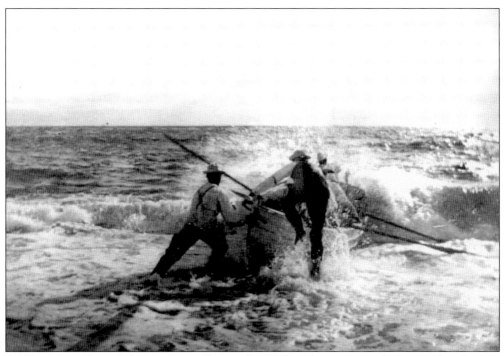

Surf boat launching drills were precisely timed, and the lifesaving crew had to work as long as it took to meet the required time. In the case of the breeches buoy drills, the required time was two minutes. (Courtesy of Bernard Collins.)

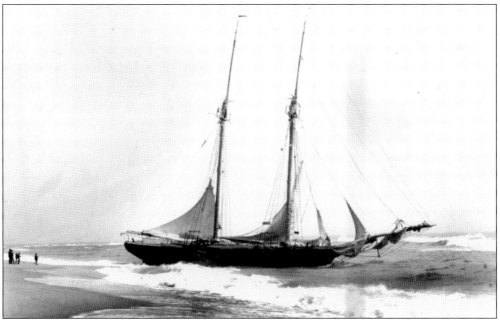

This unlucky ship is on the wrong side of the inshore sandbar. Most of the vessels that foundered were caught on the outer sandbar, where they posed a greater challenge to the lifesavers who had to fight snow, wind, hail, and giant surf conditions. To add to the danger, many wrecks hung up at night when visibility was severely hampered.

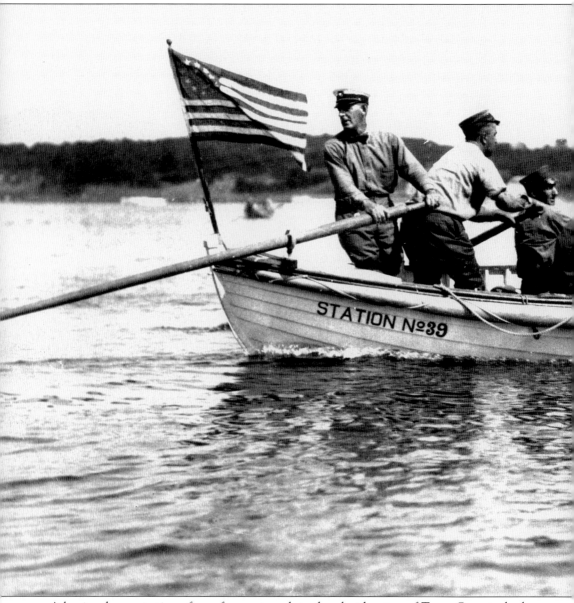

A benign demonstration of a surf crew at work in the placid waters of Town Cove took place during the Old Home Week celebration on August 19, 1921. Capt. Abbott Walker of the Nauset Coast Guard station, 56 years old at the time, is on the left manning the steering oar. Several years later, he would play a dramatic part in a less placid scenario. On January 14, 1925, in a howling nor'easter gale, an S-19 submarine foundered on the treacherous outer bar. The tug *Resolute* and the Coast Guard cutters *Tampa* and *Acushnet* arrived on the scene. They were joined by the U.S. Navy tug *Wandank*. Hawsers were placed aboard the submarine, but when rescue crews began to haul, the U-boat heeled to port by 35 degrees. By now, the crews of the S-19 had been on board for over 60 hours. This excerpt, taken from a newspaper account, describes the part that Abbot Walker went on to play in the drama: "Captain Walker Spilled Again! Another near tragedy occurred at the height of the work in the morning and gave thousands a thrill when Abbott H. Walker, the 60-year-old captain of the Coast Guard station

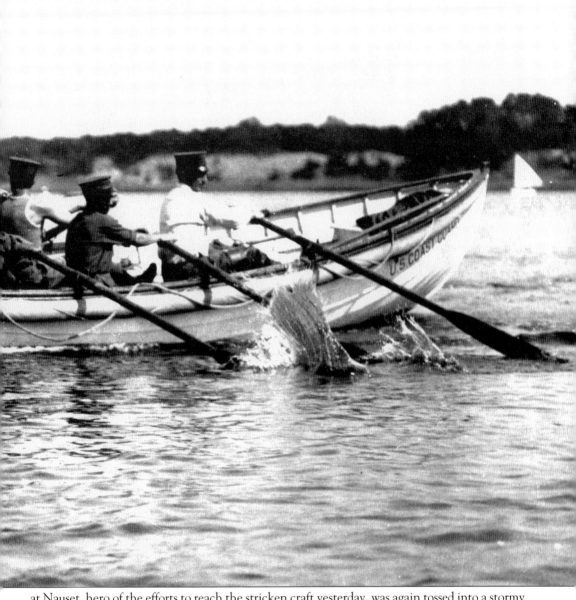

at Nauset, hero of the efforts to reach the stricken craft yesterday, was again tossed into a stormy sea while leading his men—practically all of them exhausted and tired like himself—to a task in the rescue work that had been assigned to them. The plucky veteran captain . . . had directed the launching of his surf boat and was standing in its stern steering while his men pulled at the oars as the boat went towards the submarine. A message from headquarters had come to the Nauset station asking that the crew . . . go out and carry a towing line from on the rescue boats to the submarine . . . Captain Walker and his crew were about 200 yards offshore when a big comber caught the steering oar, twisted it out of the captain's hands and . . . Captain Walker was tossed in the seething waters. As was the case yesterday his life jacket kept him afloat and within a minute or two willing hands of his crew had hauled him back into the boat and powerful strokes were sending it back towards the shore."

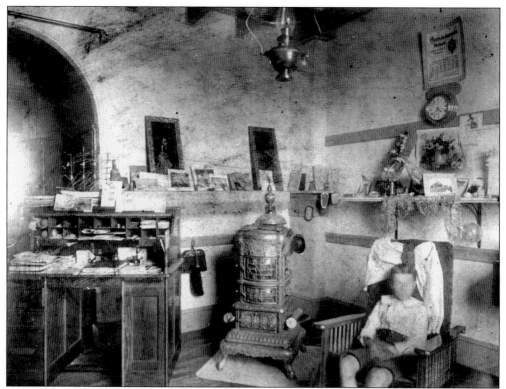

This unusual interior shot of a lifesaving station, taken *c.* 1892, was actually photographed at the Salisbury lifesaving station. It is included here because the keeper at the time was Capt. Weston Taylor, an Eastham man who, with his wife and 10 children, reluctantly left the Cape to accept a new promotion. The small boy in the chair is Taylor's son Elmer. (Courtesy of Marilyn C. Schofield.)

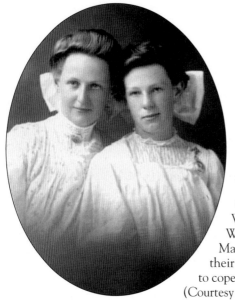

Captain Taylor's son Elmer married Captain Walker's daughter Sarah Walker in 1912. Sarah Walker is shown here on the right with her sister. Many stations heads communicated regularly, and their families had much in common, especially having to cope with fathers who were only home one day a week. (Courtesy of Marilyn C. Schofield.)

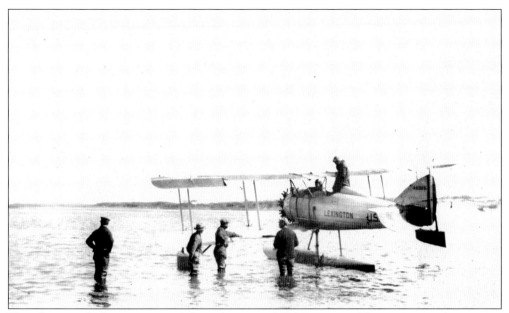

This photograph shows an aircraft from the carrier USS *Lexington*. The airplane underwent sea trials off Cape Cod in late 1927 and early 1928. Shown are Lew Collins (leaning on the wing) and three workers who had been working on Collins's shellfish grant. (Courtesy of Ken Collins.)

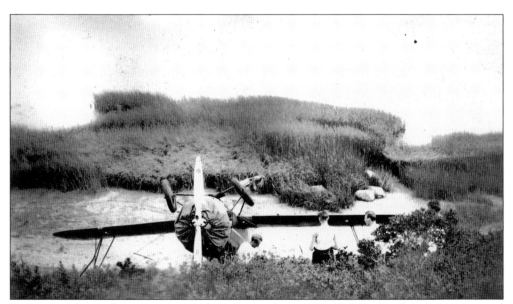

For those who had been introduced to flying during World War II, there was a natural transition to recreational flying after the war. Unfortunately, accidents like this one were bound to occur. Pastures, beaches, and country roads became hosts for these flying mishaps.

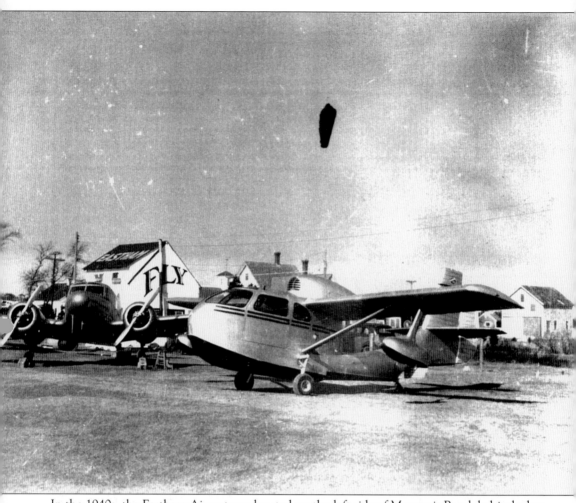

In the 1940s, the Eastham Airport was located on the left side of Massasoit Road, behind what is today the Fairway complex. When pilots were leaving Boston after hours, they would call Jay Schofield, who lived across the street from the airport. He would run and light smudge pots to illuminate the proper runway according to wind direction.

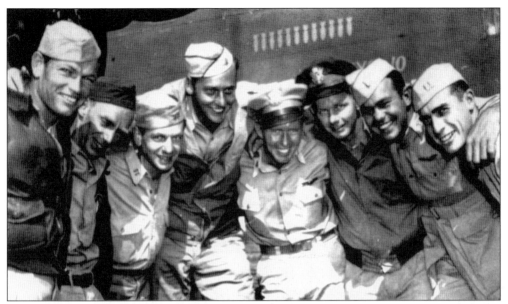

The "famous seven" flew the top-secret Doolittle raid in World War II. Pictured from left to right are ? Radney, Ed Horton of Eastham, ? Crouch, ? Minch, ? Holstrom, ? Fitzhugh, ? Youngblood, and ? Campbell. The raid on Japan had been planned to occur a day later but was moved up in response to the sighting of a Japanese fishing boat in the distance from the USS *Hornet*. The men were ordered to leave immediately, and 16 planes left the deck of the *Hornet*. Because the raid had to be scheduled suddenly, it was clear to all who left the *Hornet* that morning that they might have to ditch because of inadequate fuel supplies. The orders were to "try to land near a ship or an island" when they went in.

The members of the Doolittle raid held a reunion in 1969. Ed Horton is pictured in the right foreground.

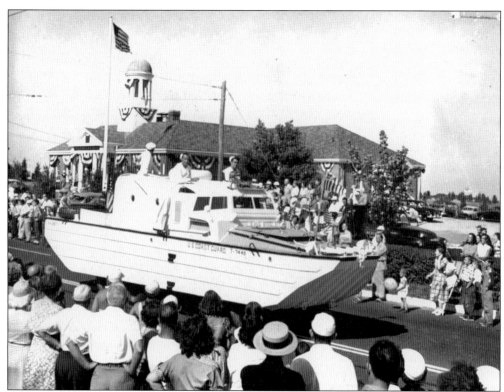

The Eastham Coast Guard DUKW appeared in the 300th anniversary parade in 1951. From left to right are coastguardsmen Ralph Jones, Don Gesch, and Warren Quinn. This model of amphibian land-to-water craft was used in the 1950s but soon phased out with the advent of more sophisticated rescue craft.

Coastguardsmen give a breeches buoy demonstration. The man who is the model for the "distressed mariner" was the mayor of East Ham, England. (Courtesy of Warren Quinn.)

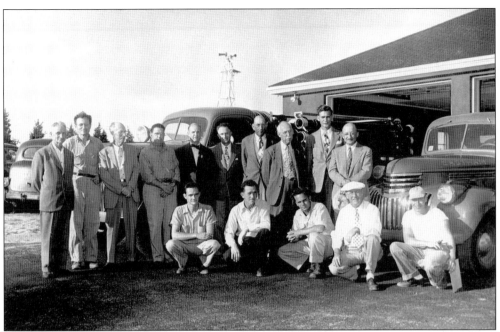

A group of town fathers and volunteer firemen join in the 300th birthday celebration of Eastham. They are, from left to right, as follows: (front row) unidentified, Caron ?, Jay Schofield, unidentified, and unidentified; (back row) Arnold, Maurice Moore, unidentified, Horace Moore, unidentified, unidentified, Lewis Collins, and Alfred Mills. (Photograph by Kelsey.)

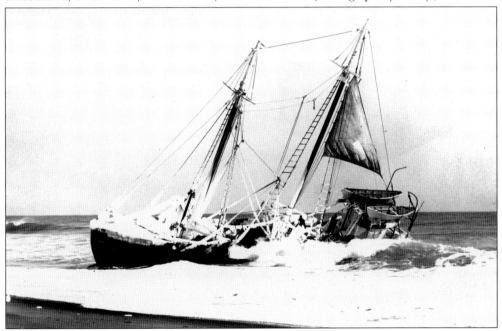

The 1948 wreck of the *Cape Ann*, iced-up and on the shore, brought the inhabitants of the Cape out in droves. It was beautiful to see in the sunlight the next morning after it hit the beach. The ice had caked the vessel's lines, and with the midnight-blue hull and orange-red dories, it looked as if nature had created a frosted confection.

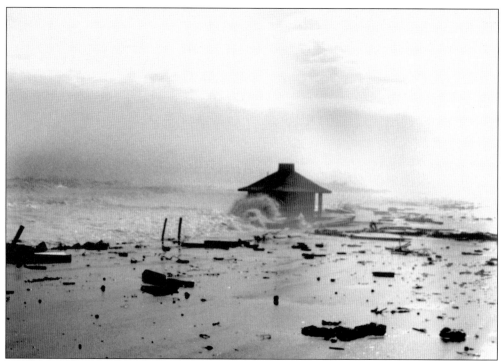

In today's world of technology, we rarely see wrecks along the beach. Yet nature still roars. The storm of February 1978 created massive havoc. Shown here is the destruction of the beach, parking lot, and bathhouse at Coast Guard Beach. (Photograph by Marilyn C. Schofield.)

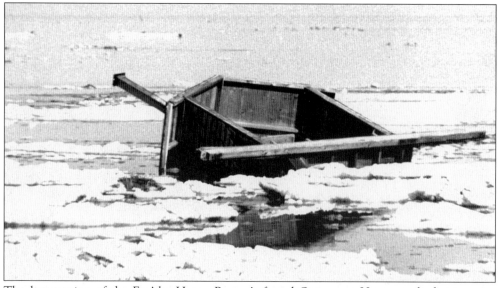

The last portion of the Foc'sle, Henry Beston's famed Outermost House washed out to sea during the February 1978 storm. Beston spent a year on the outer beach writing his observances of 12 months of life on the Cape, later published as *The Outermost House* and now considered a classic. He depended on the men at the Coast Guard station for his supplies and other needs. (Photograph by Marilyn C. Schofield.)

Five

PLACES AND FACES

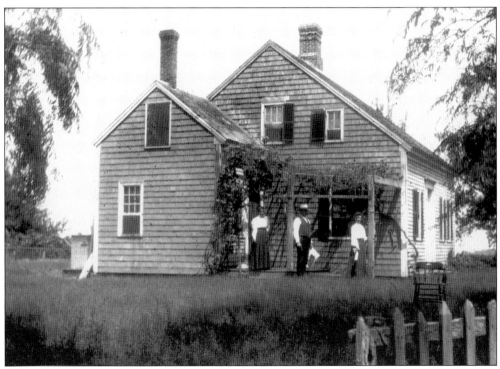

This photograph shows the start of summer visitors to the area. This is the Hotel Almena in July 1905.

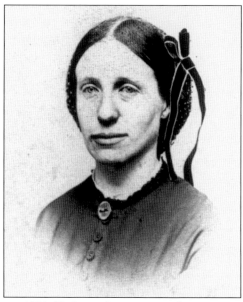

Left: Capt. Edward Penniman was born in Eastham in 1831. He began his career on the sea at age 11 and sailed the oceans for the next 40 years. He and his son Capt. Eugene Penniman were Eastham's only deep-sea whaling captains. He returned to Eastham and built a fine home on the Fort Hill Road, which is now a part of the Cape Cod National Seashore. *Right:* Augusta Knowles Penniman was one of nine children of the Knowles family on the Fort Hill Road. She often sailed with her husband, sometimes taking their children. Augusta had her own tales to tell, which she recorded in a diary that was recently published by the Cape Cod National Seashore.

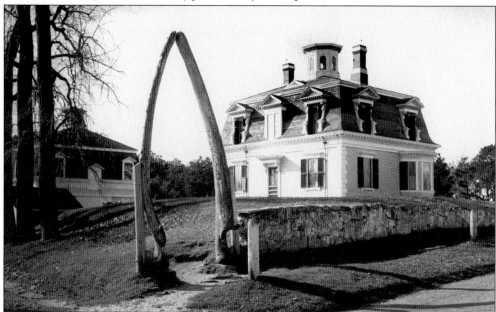

For many years, these whale jaw bones framed an entrance to the Penniman home. They can now be found at the Pilgrim Monument and Provincetown Museum in Provincetown. The Penniman house still stands today on a knoll on the Fort Hill Road. It is maintained by the Cape Cod National Seashore.

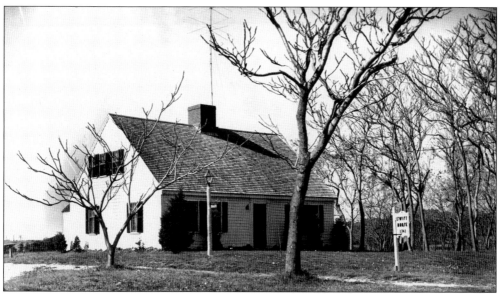

The Swift-Daley house (built in 1741) is a full cape on a highway that now runs through Eastham. It was lovingly restored by the Daley family after years of neglect. Verena Daley entrusted it to the historical society, with an agreement that she would reside there for the rest of her life. It is now the second of the Eastham Historical Society's museums. The name of the house has a unique story. At one time, Gufstuf Swift owned the house. He was a butcher and went neighborhood to neighborhood with his wagon to sell his meat. An ambitious young man, he soon decided he could do better if he went off-Cape with his business. After a few years, he followed the market to Chicago, where he and his family helped to found the Swift meat-packing company.

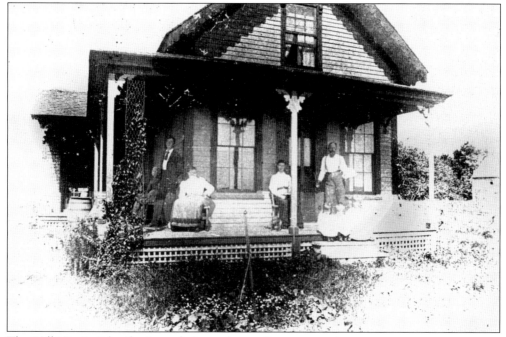

The "All Higgins" family sit on their porch on a fine summer day.

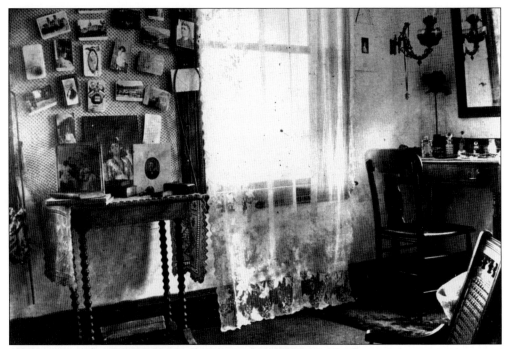

A bedroom at the Chipman's Overlook house has a Victorian look.

In 1935, a Christmas tree decorated John Stuart's home, which was the former town hall.

Town meetings were community gatherings that lasted all day with a break at lunchtime. All would go downstairs at the town hall and feast on chowders and chicken pie, homemade bread and rolls, cider, and other goodies that came in covered dishes from households all over the community. Each good wife secretly hoped that her cake or pie, hermits, or gingerbread would be considered the best until the next year when the town meeting rolled around again. When all had finished, they trooped back upstairs to resume town business and generally finish late in the afternoon. Today, the annual town meeting still follows the tradition of these earlier gatherings.

Eastham town employees gather on the lawn of town hall in the 1950s. From left to right are Belle Bracket, Ralph Chase, Roy Thomas, Betty Clandillon, L. Smith, D. Mayo, Maurice Wiley.

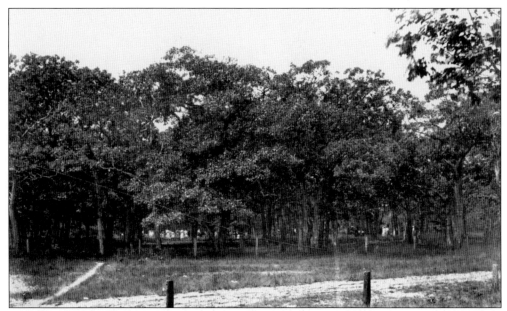

Between 1838 and 1863, the Camp Meeting Grove Corporation was allowed to use this area in Eastham, known as Millenium Grove, as a summer meeting place. Large numbers gathered to hear preachers, sing hymns, study the Bible, and share the joy and agony of penance. Emotions often reached a high pitch. Someone, with tongue in cheek, wrote on the back of this photograph, "Millenium Grove where more souls were made than saved." Later the area became known as Campground Beach and is now a popular spot.

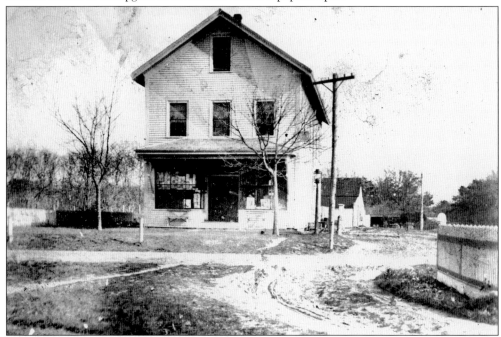

Brackett's Store, in North Eastham, carried almost anything you could use, from household to farming goods. It still stands on this corner of Oak and Massasoit Road. Today it houses the Council on Aging thrift shop.

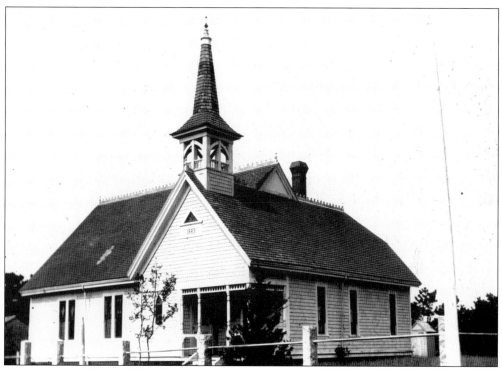

The Unitarian Universalist Church, on Samoset Road, is now known as the Chapel in the Pines. The church was built in 1890 under the leadership of Capt. Edward Penniman, who chaired the building committee. It is still an active house of worship and serves the community as a meeting space for many groups.

Rebecca Alice Knowles, a lifetime resident of Eastham, poses at age seven.

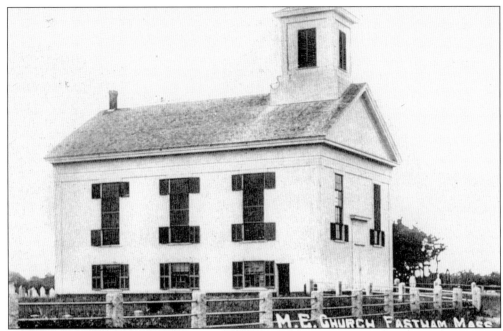

In 1851, the Methodist Society was able to build this large, imposing building with a wood-burning furnace that allowed the congregation to leave its foot warmers at home. The church had a large congregation and Sunday school.

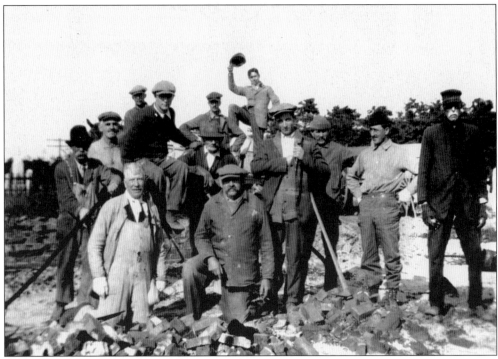

On September 18, 1920, the Methodist Society building burned to the ground. Pictured are the men of the congregation clearing the site of the fire.

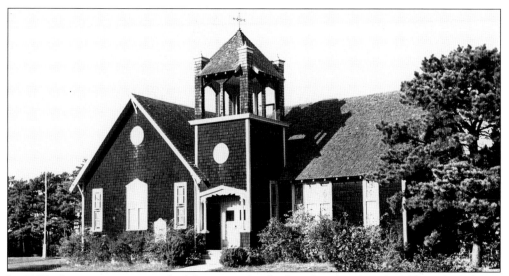

In 1925, the cornerstone was laid for a new Methodist church. This church was built by its pastor, Rev. Frank L Brooks, who also worked as a carpenter when his pastoral duties permitted. A dedication ceremony was held on March 28, 1926. In recent years, the building was moved back from the highway and an addition put on that has changed its appearance. The present church retains the original sanctuary of the 1926 church and the spirit of its forefathers.

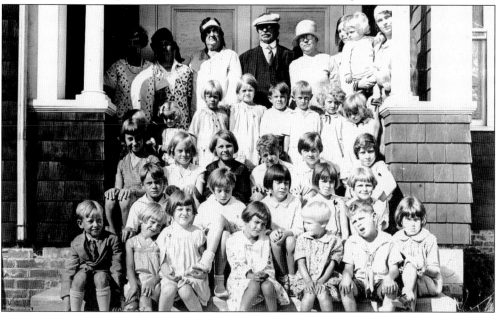

Attendees of the Daily Vacation Bible School are shown at the Eastham Methodist Church on August 20, 1929. Those pictured are, from left to right, as follows: (first row) Junior Steele, unidentified, Gloria, Carol, unidentified, Louis, and June; (second row) unidentified, Elaine, Dorothy, Mary, and unidentified; (third row) Dorothy, Lillian, Florence, unidentified, Miriam, and Methyl Turner; (fourth row) Dorothea (hidden), Evelyn, Phyllis, Betty, Junior Nickerson, Robert, and the two Forrest girls; (fifth row) Gladys Benner, Harriet Knowles, Ruth Whiting, the Reverend and Mrs. George Richardson, Emma Atwood, and Mrs. Gunn and baby. (Courtesy of Connie Whiting Cunningham.)

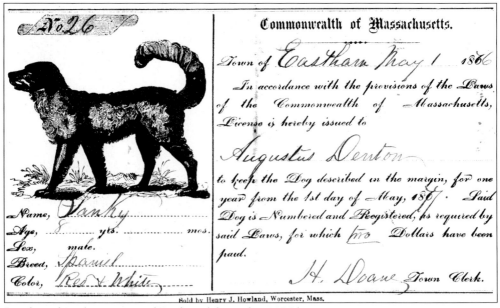

Pets have long been a part of Eastham life, as this 1876 license attests.

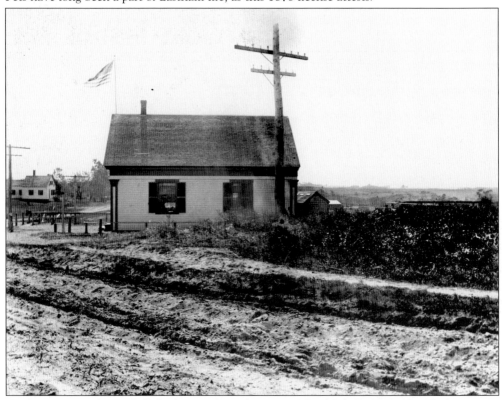

Eastham's original town hall, built in 1851 at the crossroads of Salt Pond Road and what is now Route 6, was located at the center of the town. Over the years, the building has served the town well not only as a town hall but also as temporary classroom space and meeting place. It is now a private home.

Grandma Penniman was Betsey Mayo before her marriage. She was the mother and grandmother of two whaling captains, Edward Penniman and his son Eugene Penniman.

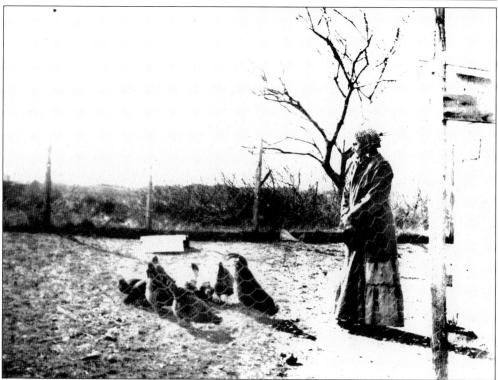

Mother Chipman feeds the chickens at Overlook. It was an everyday job for most families in Eastham in 1908.

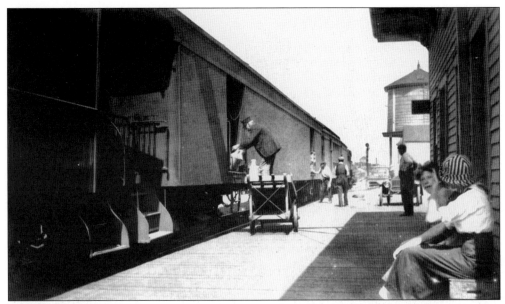

For most people, the train station was a transitory place. No one was there for long. For these men, it was a busy workplace both when the trains were due and after they had left.

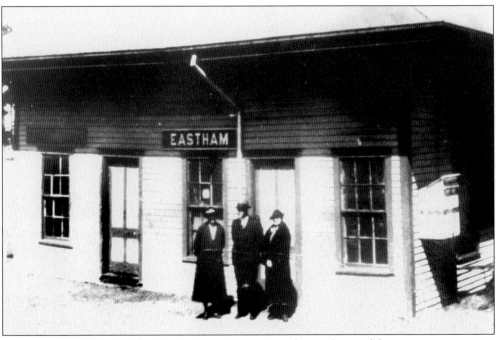

Nearly everyone came to the station at one time or another and waited for passengers to arrive or depart. The train was used by residents, farmers, and tourists alike.

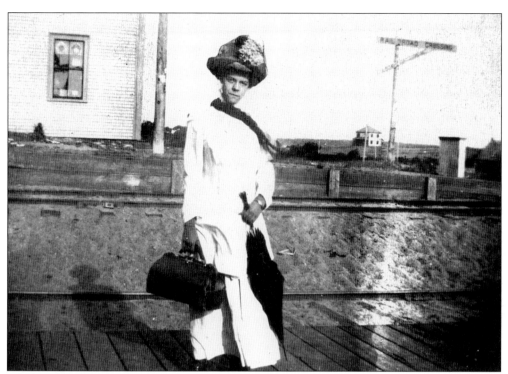

Ethel, in blue linen, awaits the train to New York in 1909.

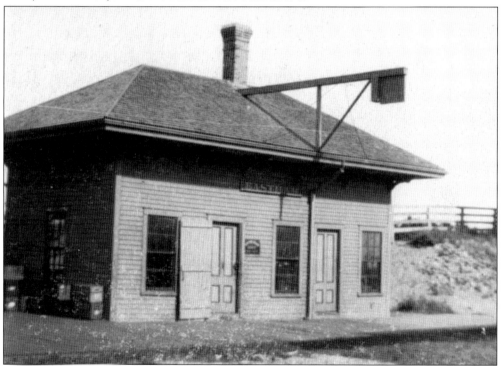

The train depot was the scene of many joyous hellos and reluctant farewells as the summer people came and went.

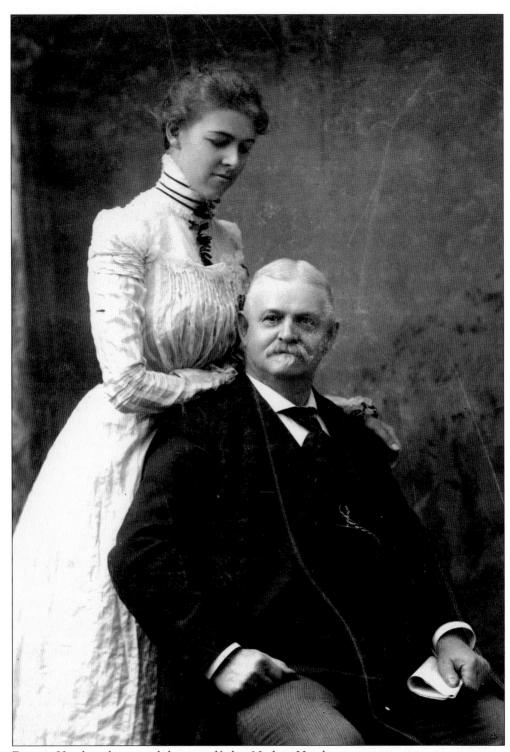

Eugenia Hatch is shown with her grandfather Nathan Hatch.

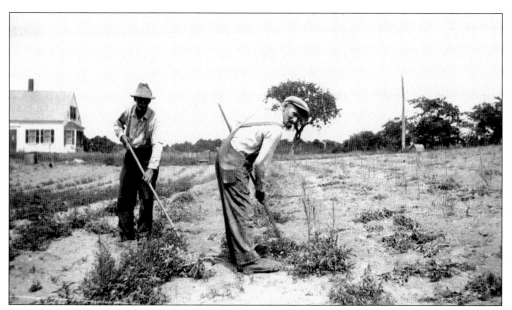

Most farming was done by families, and everyone had some responsibility to make it a success. These men are tending their turnip patch in the sandy soil of Eastham.

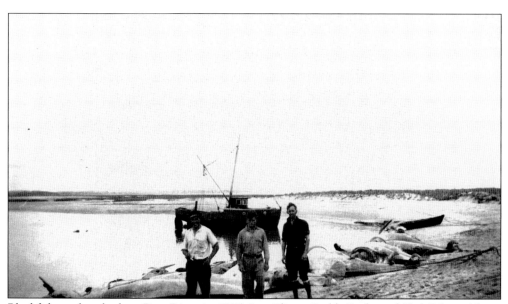

Blackfish are beached on Bees River in 1935. Joe Oliver, Buddy Rich, and Phil Schwind have come to view the sight. The phenomenon had been occurring for centuries on these bay beaches.

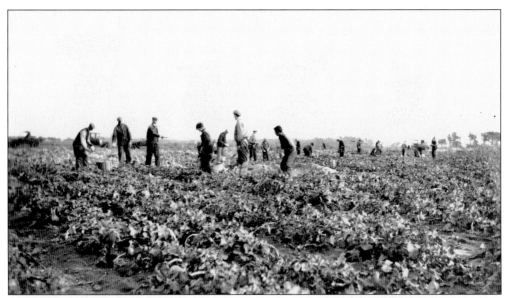

A special turnip harvest took place in the fall of 1928, when George Samuel Nickerson was struck down and with appendicitis followed by pneumonia. He was in the hospital far away from his turnip fields when they were ready to harvest. Hearing of his dilemma, friends, neighbors, and other Eastham farmers came to his aid, Early one morning, his fields in North Eastham were filled with men and boys ready to harvest turnips. By the end of the day, 1,400 bushels were ready for market. George's son Arthur recalls, "That was the way people helped one another in those days."

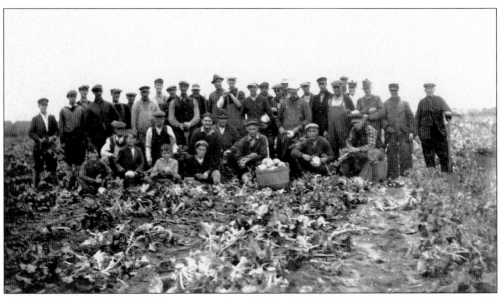

Proud and happy about their harvesting accomplishment, George Nickerson's neighbors pose for this picture before heading home.

Asparagus was king in Eastham for several years in the 1920s and 1930s. Some people will tell you it was the asparagus capital of Massachusetts at that time. Here an asparagus crew is ready to go to work in the fields of Fred F. Dill in North Eastham.

The local asparagus was readied for market by being bunched, tied, and labeled.

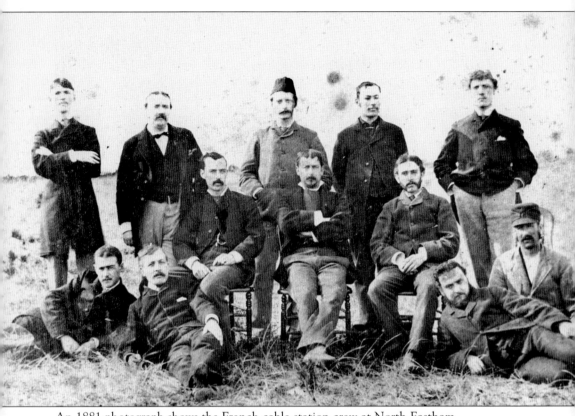

An 1881 photograph shows the French cable station crew at North Eastham.

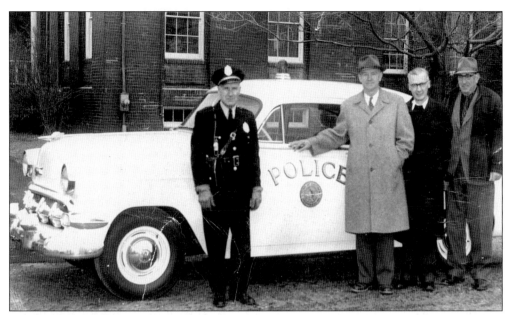

Outstanding Eastham citizens of the 1950s pose together. From left to right are Police Chief Winnie Knowles, Selectman Waurice Wiley, Luther Smith, and Bernard Collins.

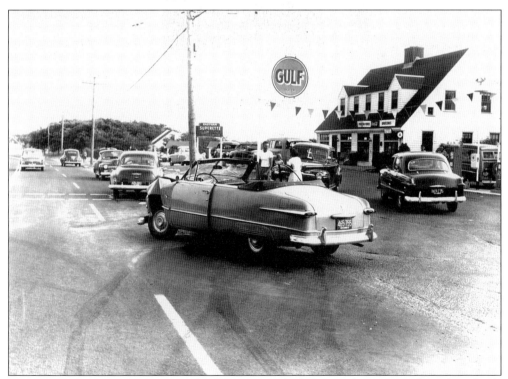

By 1952, as the traffic had increased on Route 6, so had the accidents. Even the police chief's private car was not exempt at this busy corner. Many a driver today along Eastham's busy Route 6 can relate to this picture.

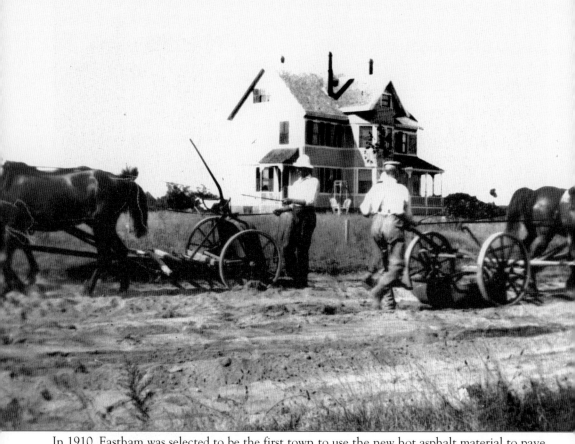

In 1910, Eastham was selected to be the first town to use the new hot asphalt material to pave the King's Highway. The roadbed was prepared with horse-drawn equipment. It is hard to imagine that this is the beginning of busy Route 6 as we know it. The Overlook is in the background.

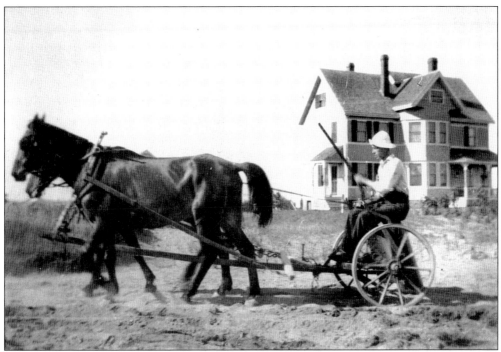

D.W. Sparrow works with a sand shovel, helping to build the King's Highway in 1910.

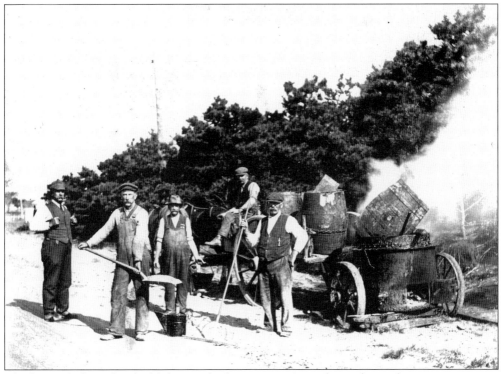

The hot asphalt used to build the new highway in 1910 was dumped out of a wagon.

This view toward the home of Seth Knowles of Fort Hill includes a rooster and pet cat belonging to Capt. Edward Penniman and depicts the whale jaw bones he owned as well.

Six
COLORFUL CHARACTERS

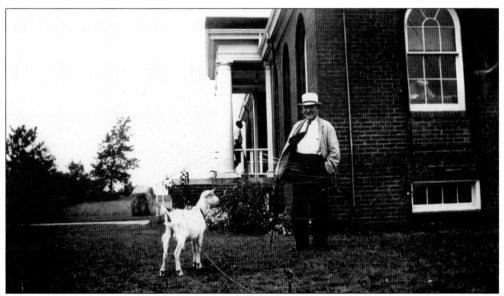

Abelino Doane, a well-known Eastham citizen, lets his goat graze on the Eastham Town Hall lawn in 1930. Perhaps Doane felt the goat could save taxpayers money by keeping the municipal lawn clipped.

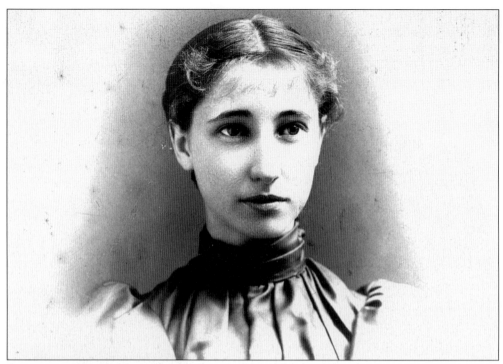

A grown-up Effie Heath poses at Bridgewater Normal School.

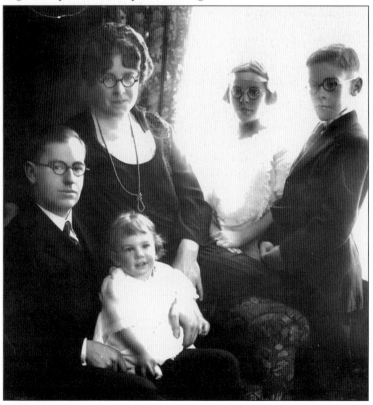

A well-dressed family poses for a formal portrait in the 1920s.

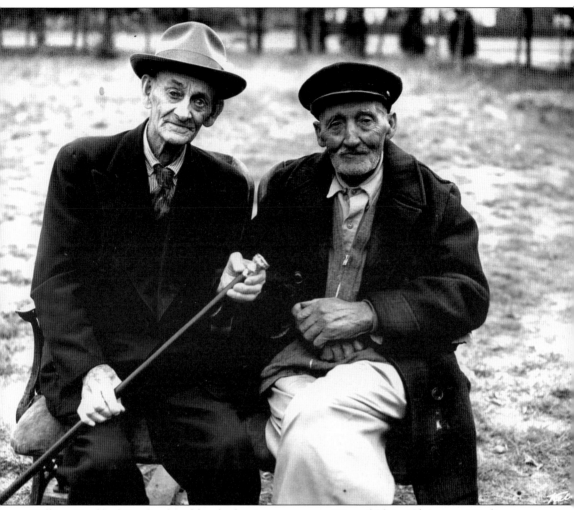

William Bradford Steele, the oldest barber in town at age 96, and Elaisa Chase, age 90, discuss the merits of the gold-headed cane presented to Steele as the oldest citizen in Eastham. When asked if he would like a cane, Chase politely answered no.

Effie Heath is shown at seven years old.

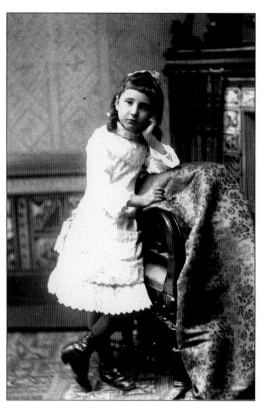

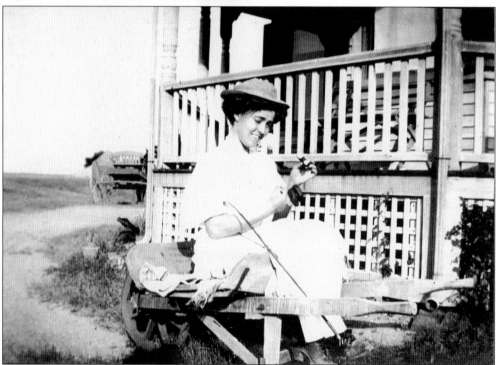

Christine Smart takes a break from gardening in 1907.

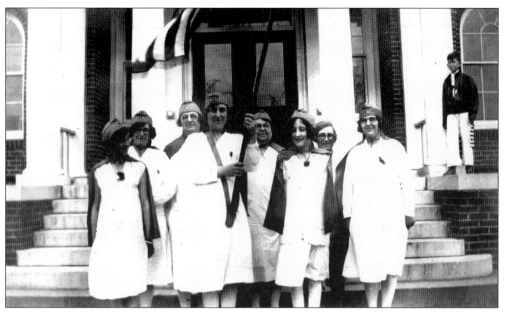

Women of the American Legion's auxiliary are posing before a Memorial Day parade.

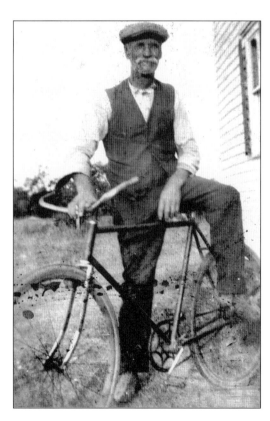

Orin Baker, out riding his bicycle, strikes a jaunty pose.

These two gentlemen, identified only as "Father and Chester," are out for a Thanksgiving Day walk in 1935.

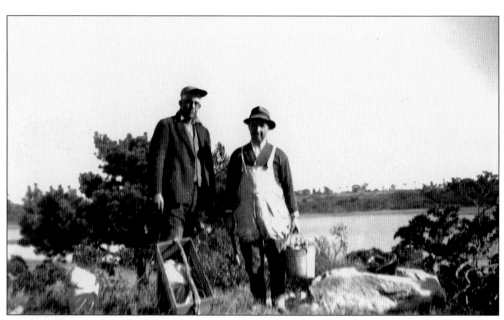

Frank Collins and Ralph Chase show off their clams following an afternoon at Salt Pond in 1942.

Thomas Gill is shown working with his sharpening stone at his farm, Wonderstrand. Gill had many fields of asparagus, the chief agricultural export of Eastham. He died on April 2, 1912.

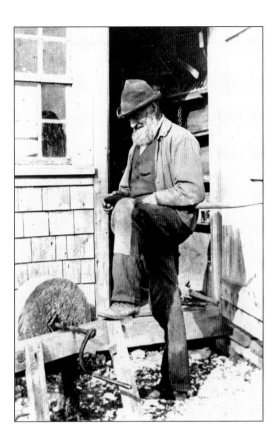

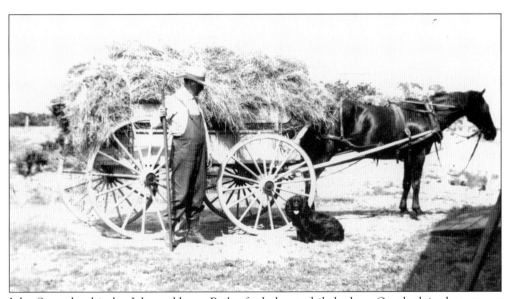

John Smart has his dog Jake and horse Bailey for helpers while he hays Overlook in the summer of 1912.

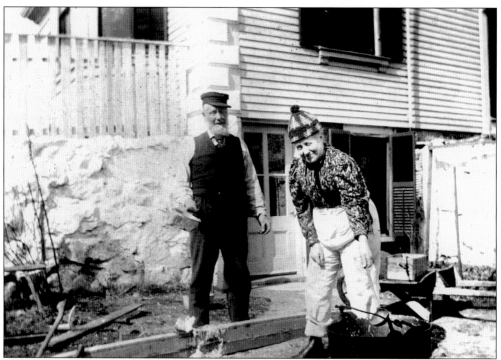

This informal photograph shows Edward and Augusta Penniman setting a lead keel for a new boat. For wearing men's trousers in those days, Augusta could have been arrested.

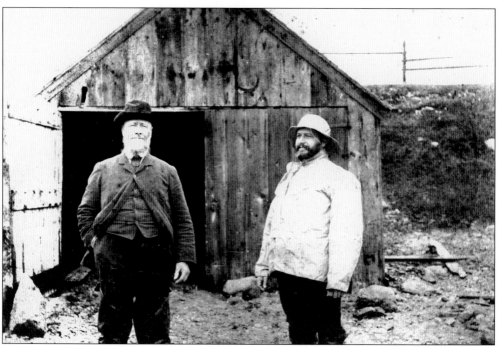

In June 1888, Capt. Edward Penniman (left) and the owner of the boat *Undine* talk over old times.

Billie Bell "Cole" (right) and her friend Betty Duncan wait for the train to arrive at the North Eastham station in 1927. Waiting for the train to come was a social pastime. You did not need to be meeting someone coming, but you might meet someone waiting. (Courtesy of Barbara Cole French.)

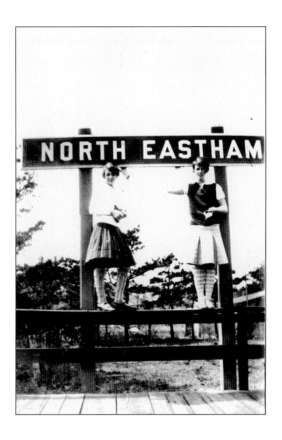

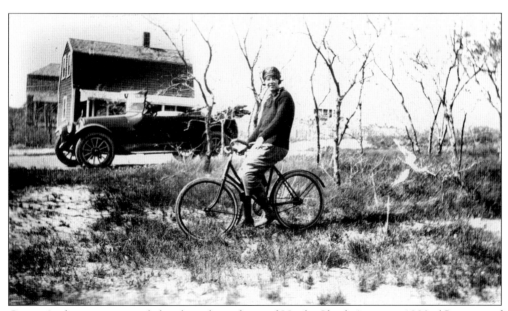

Grace Anderson poses with her bicycle in front of Uncle Charlie's car in 1923. (Courtesy of Barbara Cole French.)

From left to right, sisters Barbara, Joyce, and Nornie Johnson, with little Alice Collins, take time out from summer fun to pose for a picture in 1935. (Courtesy of Alice Collins Cook.)

Sand and wind often make picnicking on the beach a challenge, but this family seems to be making the best of it. (Courtesy of Barbara Cole French.)

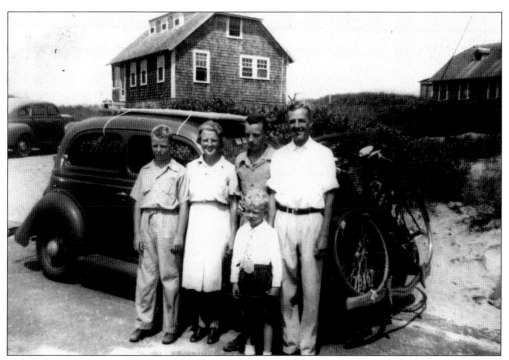

All packed and ready to leave, the Winterhalters pose for one last picture before they go back across the bridge to their other life. (Courtesy of Barbara Cole French.)

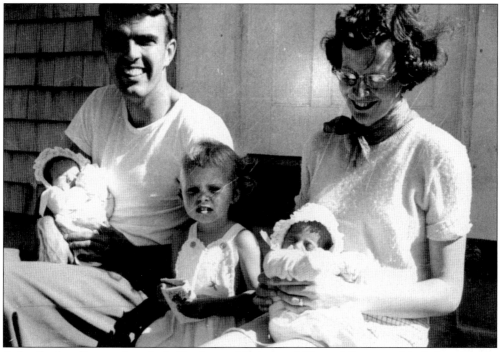

A family that lives and works in Eastham—Marion and Howard Brewer, with their new twin daughters, Debby and Sherry, and daughter Kathy—are an example of the people who make Eastham their home. (Courtesy of Alice Collins Cook.)

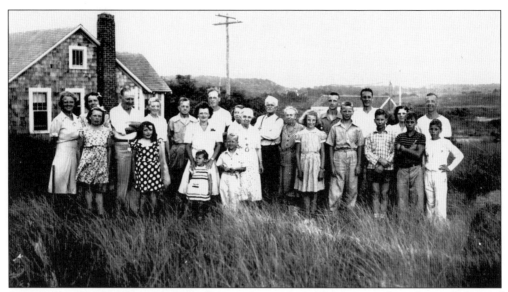

Summer families became close friends over the years, as demonstrated in this gathering of Campground Beach families. They have come together to say farewell to Roddy Phipps before he leaves for active duty in World War II.

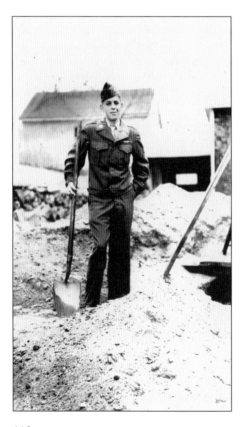

With shovel in hand, Roddy Phipps poses for one last snapshot before leaving for war.

Summer neighbor Bud Cole wrote a farewell poem for Roddy Phipps: "Every summer for many a year / Roddy's been one of the first to appear / To greet us with that boyish grin / And cheery—"hi how've you been" // Just a barefoot boy with cheeks of tan / He'll lend a hand whenever he can / To help a friend, his Mother or Dad / And nothing ever makes him mad. // He loves to fish and chase the seal / from off the island in our bay; / But the girls to him have no appeal / except to duck them, or so he says. // But now we're told that Uncle Sam / Has said that Roddy is a man, / and to match those cheeks of ruddy tan he must wear an army suit of tan. // So Roddy we have gathered here— / the friends you've made from year to year, / to wish you luck as you leave us now, / to help brother Bob show them how! / God bless you and keep you steadfast.

113

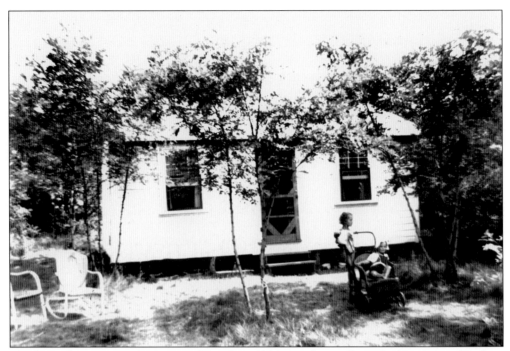

The look of a cottage at Campground Beach in 1944 was plain and simple. (Courtesy of Barbara Cole French.)

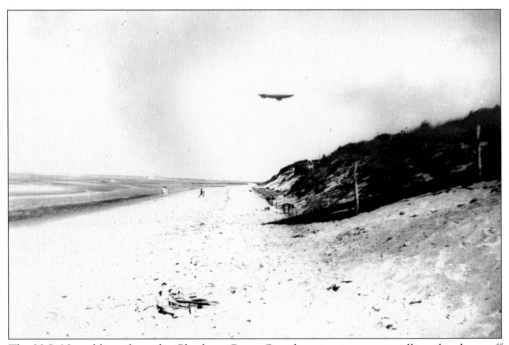

The U.S. Navy blimp from the Chatham Coast Guard station is seen patrolling the shore off Campground Beach during World War II. (Courtesy of Barbara Cole French.)

Seven

PARTING SHOTS

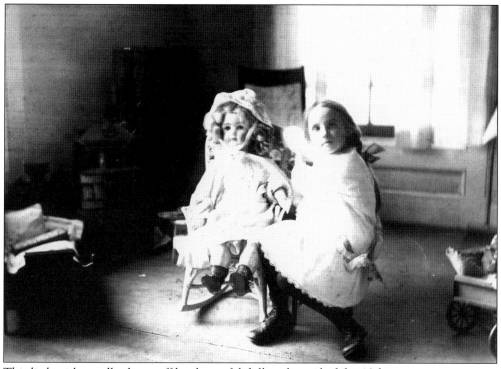

This little girl proudly shows off her beautiful doll at the end of the 19th century.

The southeast view of Salt Pond shows part of the old golf course. Because the area today is heavily wooded with cedars and scrub oak (formerly the southern portion of the Cedar Bank Links), the house can no longer be seen.

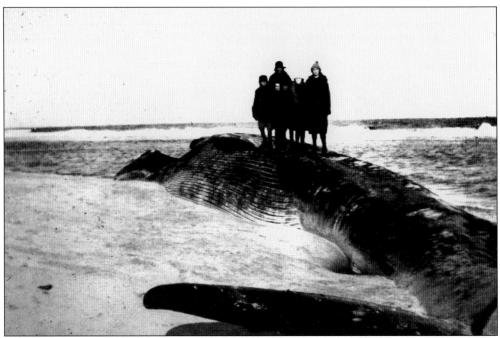

Whales have been a part of Eastham's history because of the area's geography. Here, an Eastham family takes advantage of an opportunity to give us this extraordinary picture.

Pictured here is the red Doane homestead on Nauset Road. It was the home of Ralph Chase and his wife, Hiroki.

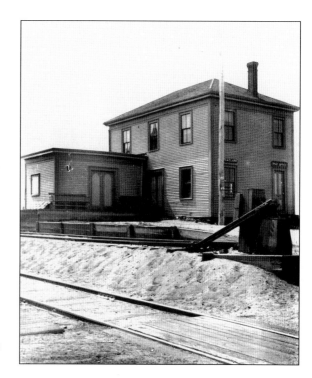

This is the George N. Clark store, beside the tracks at the Eastham train depot, in 1906. It also served as a post office.

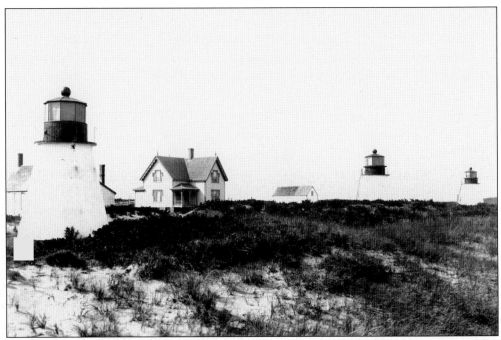

The Three Sisters lighthouses originally stood at the top of the bluff at the end of Cable Road. They were later replaced by the present Nauset Light, which is known as the "sweetheart" light. Its three-flash sequence has always been called "I Love You." As a girl, the author would sometimes be allowed to observe the manual lighting of the lighthouse. This entailed climbing to the top and igniting the gigantic mantle with its white-hot light. It would also have to be turned off at daybreak.

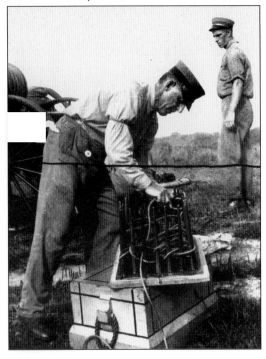

When the men returned to the lifesaving station after a rescue, all equipment had to be in readiness for the next emergency. Here Captain Walker recurls the line from the Lyle gun into the "faking box."

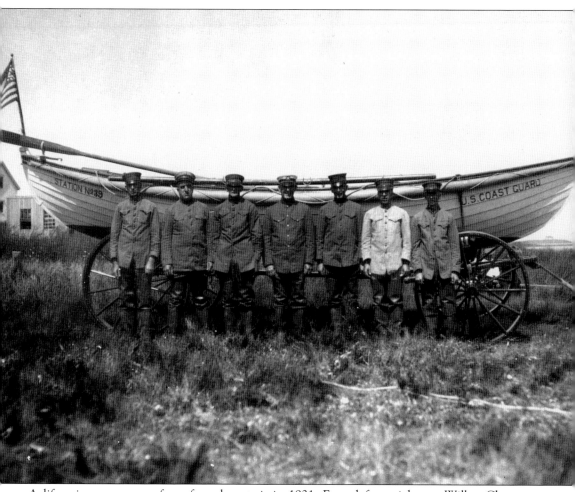

A lifesaving crew poses for a formal portrait in 1921. From left to right are Wilbur Chase, Manuel Gracie, Warren May, Capt. Abbott Walker, Henry O. Daniels, Manuel Henrique, and Walter Eldridge.

Celebrating Eastham's past are Viking explorers and the English settlers at the tercentennial parade.

A float in the tercentennial parade depicts Constance Hopkins Snow, a *Mayflower* passenger, and her husband Nicholas Snow. They were early settlers of Eastham. Ancestors of Harry Snow represent the characters. They are, from left to right, Donna Mayo, Mary Mayo, Ann Snow, and William Snow.

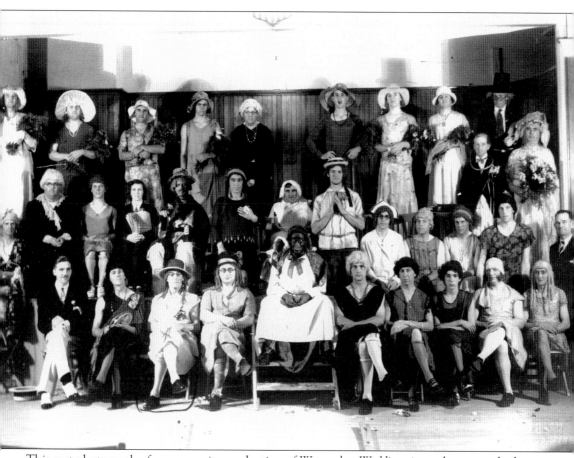

This cast photograph of a community production of *Womanless Wedding* gives a humorous look into the social side of Eastham in the 1930s. The all-male cast included teachers, lifesavers, selectmen, farmers, and fishermen.

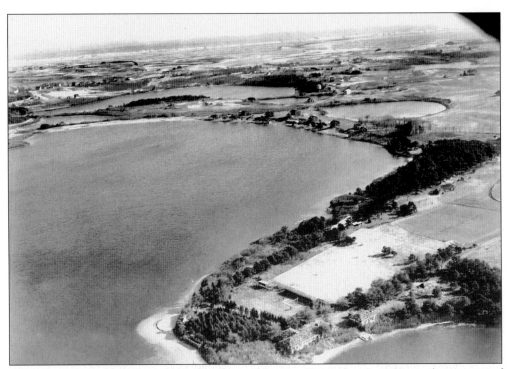

This aerial photograph over Great Pond was taken on December 2, 1928, at the request of Quincy Adams and Wyman Richardson. They had a hunting camp, which is located to the lower right.

Many yards and homes of the lower Cape have mementos of casualties of the sea. Ships that broke up on the outer sandbar carried a variety of products, some of which found homes ashore. Memorable among these treasures have been a load of blueberries out of Maine, an entire cargo of lathes from the *Montclair*, and even silver dollars. Pictured here is the figurehead of the ship *Imperial c.* 1895.

One of the old Eastham landmarks, the Patterson House (near the dump) was also known as the Haunted House. (Courtesy of Bernard Collins.)

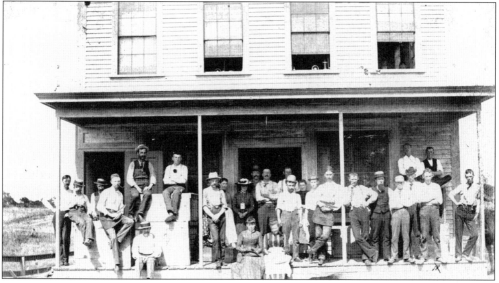

The old pants factory in Orleans provided work for many men in Eastham and Orleans. It stood where the Snow's Store addition stands today. This photograph was taken on September 29, 1890.

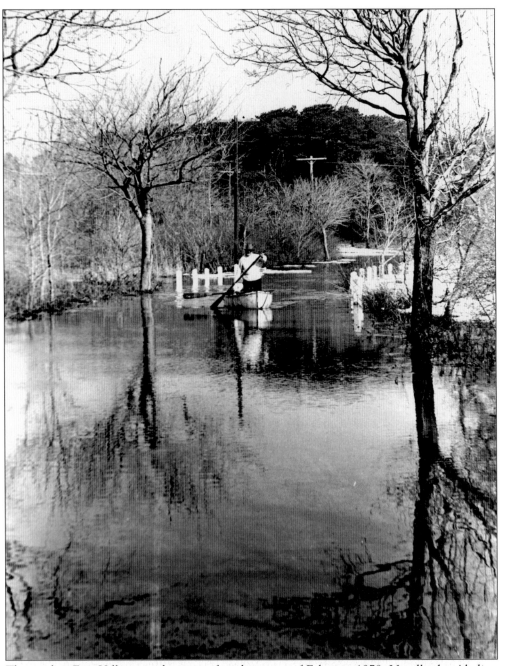

The road to Fort Hill was underwater after the storm of February 1978. Usually the Abelino Doane Creek, which runs through a culvert under the highway, is a gentle little tidal stream.

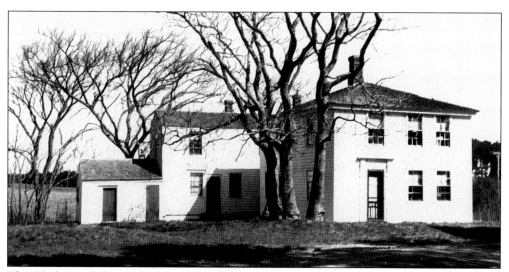

The Clark-Hatch house, built in 1802, still stands on Samoset Road in Eastham.

A senior class of Orleans High School filled with many Eastham students poses before leaving on a class trip to Washington, the highlight of senior year and the result of students' hard work earning the money to make it possible.

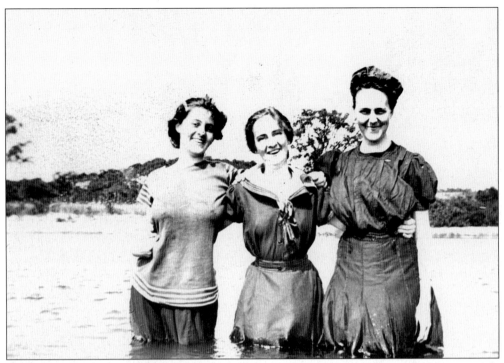

These bathing beauties at Great Pond in 1908 are, from left to right, Celia Horton, Ada Horton, and Florence Tag.

Many Eastham citizens found employment where the "summer people" played. Shown here are workers at the Cedar Barn Lodge in 1936. They are, from left to right, Gertrude Moore, Chef, George Moore, and his wife, Ann J. Moore.

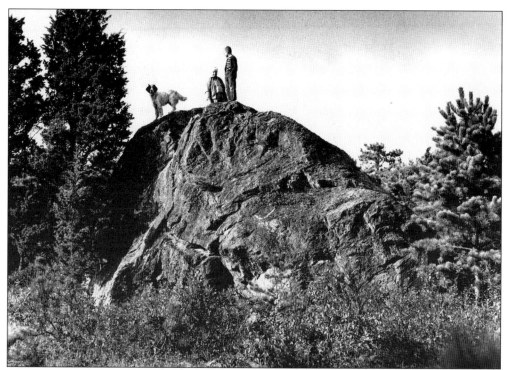

Glacial remains can be found all over the Cape. This large rock off of Doane Road is a memorable sight. Through the years, it has had many names, including Enock's Rock, the Great Rock, and today Doane's Rock.

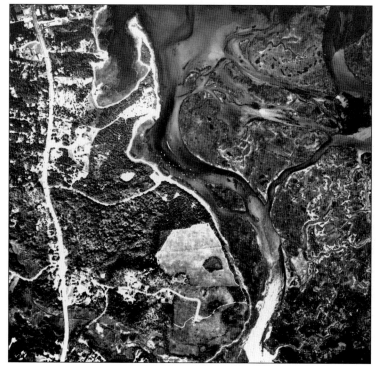

An aerial view shows the curves of the channels east of Fort Hill and Skiff Hill. The large patch at the center is the open field at Fort Hill, formerly pastureland for Nauset Moors Farm.

This lovely lane leading to Fort Hill and the Nauset Marsh panorama is a great place to say goodbye to our past. We leave our roots to all our children, and to their children. Our everyday lives that seem ordinary and unremarkable are their precious heritage. The next time you clean out your grandmother's attic or father's photo album, call your local historical society and donate these glimpses into the past for preservation. We hope you have enjoyed this jaunt back in time in this very special place named Eastham.